HomoArt

Gilles Néret

TASCHEN

KÖLN LONDON LOS ANGELES MADRID PARIS TOKYO

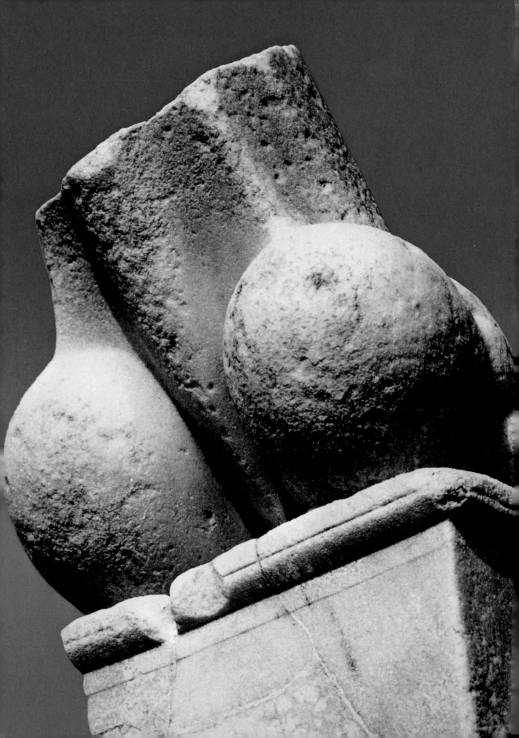

Contents | Inhalt | Sommaire

◄ *Monumental sculpture in the form of an erect phallus*, 3rd century BC. Island of Delos

Priapus and Adonis

Baudelaire advised: "Don't fight nature. If she's given you a mistress who is flat-chested, tell people instead: I've got a friend with hips. And go to the temple to thank the Gods."

The heroes of homoerotic art history can be viewed in the form of pairs. On one side is Priapus, the God of gardens, vines and fecundity, the son of Dionysus and either Aphrodite or a nymph, the personification of virility. On the other is Adonis, a Phoenician divinity, a young man from Byblos of remarkable beauty, who was mortally wounded by a boar and changed into an anemone by Venus. He is the symbol of effeminate beauty. Eros is forever shooting arrows between these two complementary and interchangeable beings.

But first let us render to Caesar what is Caesar's. Hollywood habitually portrays him in love with Cleopatra, but Cicero, who knew him well, was closer to the truth, speaking in his letters of the Roman dictator's infamous affair with Nicomedes, the King of Bithynia, which led Suetonius to impugn him on the floor of the Senate as "the wife of all men, and the husband of all women". Other senators followed suit, vilifying him in choice terms ranging from "the King's concubine", to "Nicomedes' whorehouse" or the "Bithynian prostitute". Back then no one minced their words, and Caesar gave as good as he got: "Granted, I did act as Nicomedes' wife, but I know many women a thousand times more manly than you."

Homosexual imagery is generally somewhat impoverished, when one takes account of the all taboos and interdictions that surround it, and if there ever was a Golden Age of Pederasty, it would have to be Greco-Roman times. But down the centuries we can still discern its hidden face, as when Ingres or David, perhaps unconsciously, emphasis its virile or effeminate side in the way they depict a male nude. Plato taught that "In previous times, Nature was not as she is today, but different. Humanity was divided into three genders, and not two as now. As well as men and women, there was also a third sex sharing attributes of the other two. The species was destroyed, and only the name subsists. These were the Androgynes whose name and appearance recalled simultaneously the male and the female sex." Perhaps the wise man, when he turns to the ephebe, a young man with a feminine soul, does not seek to satisfy a specific physical desire, but rather strives to find an echo of that Golden Age on the sexual and spiritual plane. But that Golden Age never returns. And since its disappearance, those who hanker after this androgynous state find

◄ **Anonymous** Engraving for *Dom Bougre* or *Le Portier des Chartreux*, 1749 5

themselves on opposite sides of a mountain, their hearts crying out vainly to be reunited with their opposite number. However, they sometimes come very close to the crest that divides them. Caesar and Michelangelo are two examples.

The Greeks, like the Gods that they invented, worshipped happily at the altar of Uranus, as a matter of principle, fearing they would be softened by women they found as empty and dark as the mouths of the caves that led down to the underworld. Sophocles, Euripides and Phidias were the high priests of this creed, and poets like Pindar and Theocritus spoke now of Eros as a god, now as a commonplace passion. Shepherds in their idylls spoke frankly: "When I was skewering you, you didn't seem so proud," says Cometas to his friend Lacon. They evoked Hercules' mad love for the child Hylas "with his long curly hair". Plutarch also mentioned the favourites of Demetrius Poliocretes, one of whose naval triumphs is possibly commemorated by the Winged Victory of Samothrace: "One day Demetrius was sick. His father went to see him, and met a beautiful young man who was on his way out. Demetrius reassured his father, saying 'the fever has left me now.' 'I know,' said his father, 'he was leaving when I arrived.'" In Rome, Seneca summed up the morals of his time as follows: "A passive sexual role is a crime for a free man, an obligation for a slave, and a duty to a freedman." That rule was encouraged by heads of state from Caesar to Tiberius, whose excesses were a constant source of scandal. Caligula, the prince of depravity, married his horse; Nero castrated his slave Sporus and then took him for a wife. Under his reign, the delightful Petronius, in the Satyricon, recounted the scandalous adventures of Encolpius and Gito, whose name became a byword for a young man kept for pleasure. Sculptors made innumerable statues of Antinous, a young Greek of exceptional beauty from Bithynia who was the favourite of Emperor Hadrian, who elevated him to the realm of the Gods and had images of his features made by the greatest artists of the day. Antinous was the inspiration for countless ancient statues, and today is the gay icon par excellence.

The cult of the body and the virile beauty that the archaic kouros represented resembles that of the Gods of Myron, Praxiteles, Polycleitus and Lysippus – the list is endless. By no means all the Caesars were effeminate. They could be virile soldiers too, like Galba, or Augustus, who gave his name to a whole century. Moralists always forget that the Iliad – which is taught to schoolchildren – revolves around the love of Achilles for Patroclus. Frederick the Great's quip is as precise as a military report: "Love is a perfidious God. Resist his face, and he'll turn round and show you his rear."

Sodomites had a rough time in the Middle Ages, as they were burnt on the slightest suspicion of irregularity. Gilles de Rais, better known as Bluebeard (1440), admitted during his trial that "It was by reading a book by Suetonius, embellished with

▶ **Anonymous** Engraving for *Dom Bougre* or *Le Portier des Chartreux*, 1749

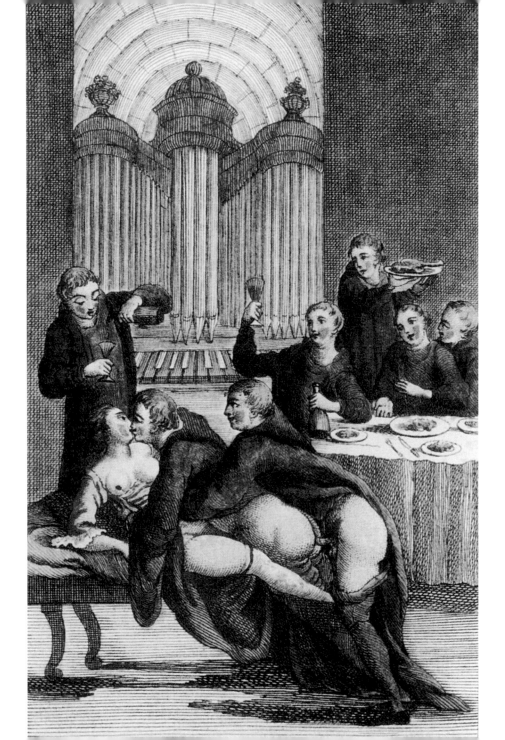

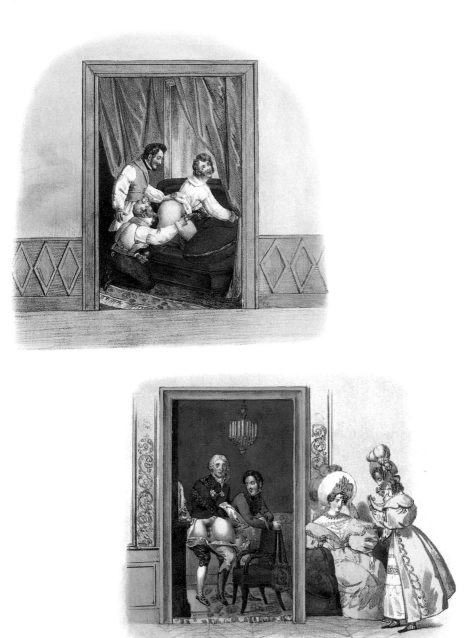

Doors and Windows. Two erotic prints from an early 19th century collection of lewd images.
Above: Ah! What a sweet little arse! ... Below: Ah my dear, how wild you are...

beautiful images, about the life and times of the Caesars, that I was inspired to copy the excesses of Tiberius, Caracalla and all the others." The Renaissance, on the other hand, which revolutionised the history of art, was the work of great homosexuals who were known and respected as such, from Botticelli to Raphael. As a young man, Leonardo da Vinci was involved in a homosexual affair, and Giovanni Antonio Bazzi, known as Il Sodoma, was proud of his name. Caravaggio lost his fortune and was constantly shunted from one prison to another, as he was unable to hold his impulses in check and raped the adolescents that he painted, even if they were young noblemen. At the same time Shakespeare was writing sonnets to a younger man of his acquaintance, and Michelangelo was covering the ceiling of the Sistine Chapel with Ignudi, their virile members piercing the air, and writing passionate love letters to the beautiful Cavalieri whom he loved all his life. Only a man like Michelangelo, whose aspirations and gifts blended a feminine sensibility and Herculean strength, could reconcile these apparent opposites: the beauty of androgynous young men, and the faith needed to get to Heaven. To his way of thinking, the human beauty that he portrayed issued directly from the hand of the Creator, and was to bring the souls of mortals back in touch with the God and his works. It was after contemplating his David that Arno Breker, Adolf Hitler's favourite artist, decorated public squares and Nazi buildings with naked, triumphant young men. Such works, of course, excite controversy, but equally, admiration. Warriors despise women and idolise male cameraderie : it's an old Spartan tradition…

When the Kinsey Report came out in 1948, its conclusions were something of a bombshell. It revealed that 37 percent of young men, fully two out of every five, had had a homosexual experience. But Mishima's grandiose suicide in 1970 and the very public murder of Pasolini five years later marked an end for homoerotic art. Jean Genet had stopped writing: why be scandalous in a world where scandal was constantly applauded? The Pope still preached in the desert, but the fact was men married each other, adopted children and became more and more acceptably middle class. Homosexuality, once the leaven of art, no longer represents the sort of taboo or no-go zone that formerly made it so creative. What's happened to gay art since Bacon and Warhol? It seems to have taken refuge in photography, in the work of George Platt Lynes, Minor White and Robert Mapplethorpe, whose nudes seem indistinguishable from classical statues, yet still manage to create a stir now and then. With the end of repression, homosexuality raises few eyebrows. But the change appears to have destroyed its creative impetus – Gay Pride is a case in point. Society on the whole is better for it, but arts has suffered a loss.

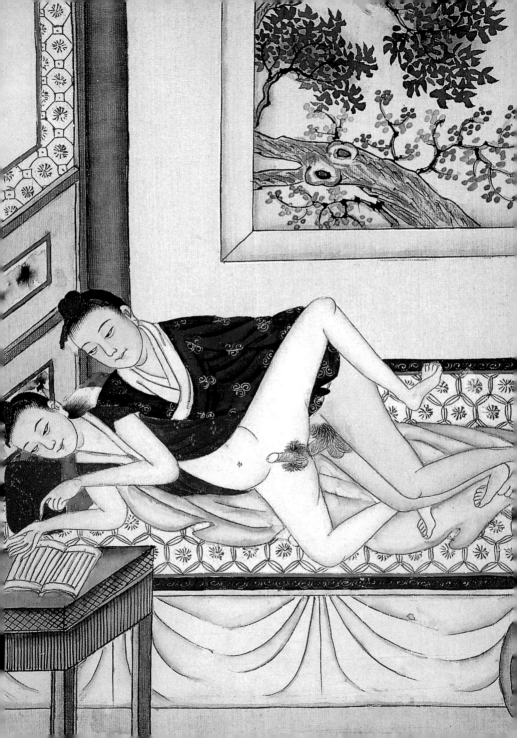

Priapos und Adonis

Baudelaire gab den Rat: „Macht niemals die großartige Natur schlecht, und wenn sie euch eine Geliebte ohne Hals beschert hat, dann sagt: Ich habe einen Freund mit Hüften. Und dann geht in den Tempel und sagt den Göttern Dank." Die Helden der Geschichte homoerotischer Kunst bilden ein Paar. Da ist einerseits Priapos, der Gott der Gärten, der Weinreben und der Fortpflanzung; Sohn des Dionysos und der Aphrodite oder einer Nymphe. Er verkörpert die Männlichkeit. Und auf der anderen Seite Adonis, eine phönizische Gottheit, ein junger Mann aus Byblos von großer Schönheit, der von einem Wildschwein tödlich verletzt wurde und den Venus in eine Anemone verwandelte. Er ist das Symbol der verweiblichten Schönheit. Zwischen diesen beiden sich ergänzenden und austauschbaren Wesen hat Eros gestern wie heute am häufigsten mit Pfeil und Bogen gespielt. Doch erweisen wir erst einmal Cäsar die Ehre, die ihm gebührt. Hollywood hat ihn meist als Liebhaber der Cleopatra dargestellt. Aber Cicero, der ihn gut gekannt hat, bleibt näher bei der Wahrheit und spricht in seinen Briefen von dessen berühmtem Abenteuer mit Nikomedes, dem König von Bithynien, das zur Folge hatte, dass er von Sueton vor den Senat zitiert und als „Frau aller Männer, Gatte aller Frauen" tituliert wurde. Alle anderen Senatoren fielen in den Chor ein und apostrophierten ihn mit weiteren ausgesuchten Begriffen, darunter „Konkubine eines Königs", „Freudenhaus des Nikomedes" oder „bithynische Prostituierte". Zu jener Zeit schreckte man nicht vor solchen Worten zurück, und Cäsar ging seinerseits in den Gegenangriff: „Es stimmt, ich bin die Frau des Nikomedes, aber ich kenne Frauen, die sind tausendmal energischer als ihr."

Die homosexuelle Bildwelt ist recht begrenzt, was auf Verbote und Tabus zurückzuführen ist, und man kann nur in Bezug auf das alte Griechenland und das Römische Reich von einem goldenen Zeitalter der Päderastie sprechen. Man könnte aber in sämtlichen Epochen der Kunst die verborgenen Anspielungen herauskristallisieren, denn Künstler wie beispielsweise Ingres oder David haben, möglicherweise nicht einmal bewusst, den männlichen oder verweiblichten Aspekt an einer Aktfigur besonders herausgestellt. Schon Platon lehrte, dass „die Natur früher nicht so war, wie sie heute ist; sie war im Gegenteil recht verschieden. Die Menschheit teilte sich in drei Geschlechter auf und nicht in zwei wie heutzutage. Neben dem männlichen und dem weiblichen Geschlecht gab es ein drittes, das von beiden Anteile hatte. Diese Spezies ist zerstört worden und nur ihr Name ist übrig geblieben. Die Gattung nannte sich das Androgyn, denn sowohl ihr Aussehen als auch

ihr Name erinnerten gleichzeitig an das Männliche und das Weibliche." Man darf aber sagen, dass der weise Mann, indem er sich den Epheben, den jungen Männern mit weiblicher Seele, zuwandte, nicht zu allererst nach der konkreten Befriedigung körperlicher Liebe suchte, vielmehr wollte er in sexueller Hinsicht und auch auf der Ebene der Sinnlichkeit eine Art goldenes Zeitalter zurückgewinnen. Unglücklicherweise ist das goldene Zeitalter nie mehr zurückgekommen. Seither ist der Mensch, der zum Androgynen tendiert, zur einen oder anderen Seite der geschlechtlichen Ausrichtung bestimmt und schreit ohne jede Hoffnung nach Vereinigung der beiden. Aber es gibt eine Möglichkeit, der Verwirklichung sehr nahe zu kommen. So war es beispielsweise bei Cäsar oder Michelangelo.

Die Griechen taten es den Göttern gleich, die sie sich erfunden hatten, und widmeten sich ausgiebig der homosexuellen Liebe, aufgrund der Sitten und weil sie sich nicht von den Frauen schwach machen lassen wollten, die sie seltsam und undurchschaubar fanden wie die Höhlen, die in die Unterwelt führen. Sophokles, Euripides und Phidias waren die Hohepriester dieses Credos und Dichter wie Pindar und Theokrit riefen den himmlischen Eros ebenso an wie den vulgären. Die Hirten in ihren Idyllen waren mit ihren Worten nicht zimperlich: „Als ich dich gepfählt habe, warst du nicht so stolz!", sagt Comatus zu seinem Freund Lacon. Sie beschrieben auch die rasende Liebe des Herkules zu dem Kind Hylas „mit den langen Haarlocken". Plutarch erinnert in dem Sieg von *Samothrace* an die Lustknaben des Demetrius: „Eines Tages war Demetrius krank. Sein Vater wollte ihn besuchen und lief einem schönen jungen Mann über den Weg, der soeben aus dem Haus kam. Demetrius beruhigte ihn: ,Das Fieber geht schon zurück, mein Vater …' ,Ich weiß, mein Sohn, ich bin ihm begegnet, als ich hereinkam.'" Seneca in Rom formuliert die herrschende Ethik so: „Die sexuelle Passivität ist ein Verbrechen für den freien Mann, eine Verpflichtung für den Sklaven, ein Dienst für den Freigelassenen." Diese Regel wurde durch die Kaiser, von Cäsar bis Tiberius unterstützt, und so verwundert es nicht, dass die Chroniken mit ihren Exzessen überfüllt sind. Die Berichte reichen von Caligula, dem Großmeister der Verderbtheit, der sein Pferd heiratete, bis zu Nero, der seinen Sklaven Sporus kastrieren ließ, bevor er ihn zur Frau nahm. Unter seiner Herrschaft lebte der unterhaltsame Schriftsteller Petronius, der in seinem *Satyricon* die skandalösen Abenteuer von Encolpius und Giton erzählt, und der Name des Knaben Giton ist seither zum Synonym für „Lustsklave" geworden. Bildhauer haben dem Antinous, einem jungen Griechen aus Bithynien, unzählige Statuen gewidmet; er war ein junger Mann von großer Schönheit und Günstling des Kaisers Hadrian; dieser erhob ihn in den Rang der Götter und ließ sein Bildnis von den berühmtesten Künstlern seiner Zeit festhalten. So wurde Antinous Vorbild für zahlreiche antike Statuen und ist heute die Ikone der Homosexuellen schlecht-

▶ *Sexual relations between two men.*
Painting on silk, Qing dynasty, 18th–19th century, China

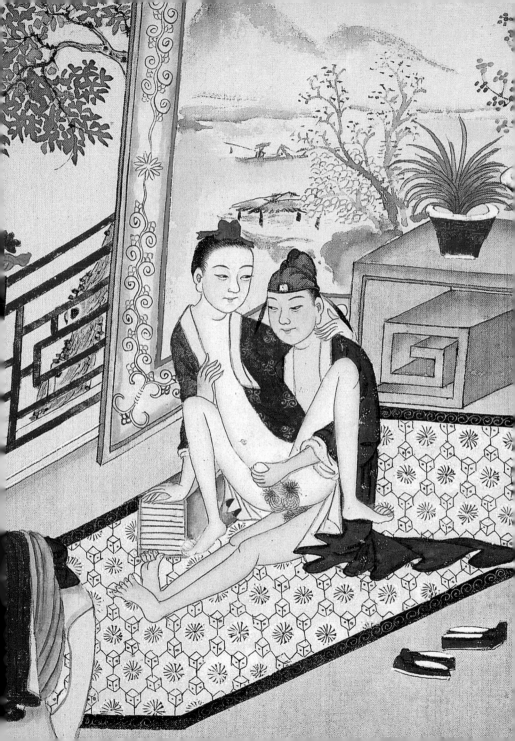

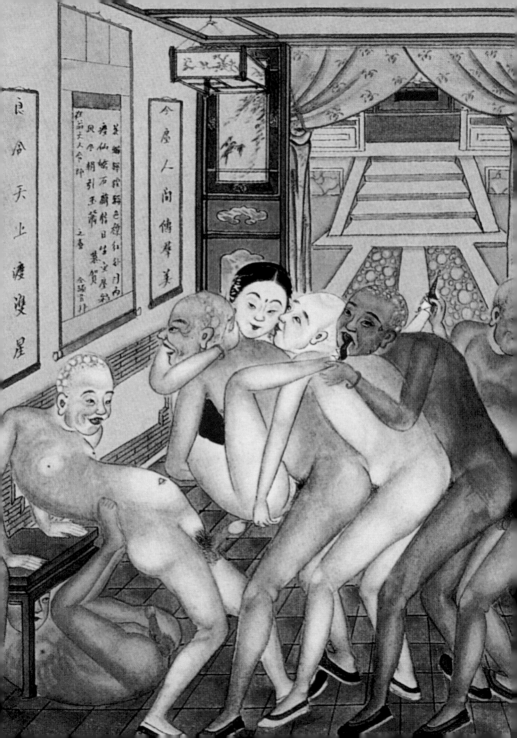

hin. Der Kult des Körpers und der männlichen Schönheit, wie er in den archaischen Kourï dargestellt ist, zeigt sich in den Darstellungen von Athleten und Göttern bei Myron, Praxiteles, Polyclet und Lysippos – die Reihe der Beispiele ist endlos. Doch bei weitem nicht alle Cäsaren waren effeminiert. Unter ihnen gab es ebenso viele höchst männliche Krieger wie Galba oder Augustus, der seinem Jahrhundert den Namen gab. Die Moralisten vergessen nur allzu leicht, dass die *Ilias* – die man Schülern zu lesen gibt – auf der Liebe des Achill zu Patrokles basiert. Der Ausspruch Friedrichs II. ist so präzise wie ein Militärbericht: „Die Liebe ist ein perfider Gott. Wenn man ihm von vorne Widerstand leistet, dreht er sich um."

Im Mittelalter hatten die Sodomiten schlechte Zeiten, sie wurden schon bei dem geringsten Verdacht auf den Scheiterhaufen geworfen. In seinem berühmten Prozess (1440) gestand Gilles de Rais, auch Blaubart genannt: „Bei der Lektüre eines mit schönen Bildern ausgeschmückten Buches über das Leben und die Sitten der Cäsaren von Sueton haben mich die Ausschweifungen von Tiberius, Caracalla und anderen Cäsaren sehr animiert." Die Renaissance hingegen, die eine völlige Erneuerung der Kunstgeschichte bedeutete, wurde von berühmten Homosexuellen hervorgebracht, von so anerkannten und respektierten Männern wie Botticelli und Raffael. Leonardo da Vinci war schon als junger Mann in eine Päderastie-Affäre verwickelt, und Giovanni Antonio Bazzi, genannt Il Sodoma, trug seinen Beinamen mit Stolz. Caravaggio verlor ein Vermögen und wanderte von einem Gefängnis ins nächste, denn er konnte seine Triebe nicht zügeln und vergewaltigte die Jünglinge, die er malte, auch wenn sie Adelige waren. In derselben Epoche richtete Shakespeare seine Liebessonette an einen jungen Mann aus seinem Freundeskreis, während Michelangelo die Decke der Sixtinischen Kapelle mit seinen Ignudi bedeckte, das männliche Glied unverhüllt, und auch er widmete seine glühenden Liebesgedichte einem schönen jungen Mann namens Cavalieri, den er sein Leben lang liebte. Ein Künstler von den Gaben eines Michelangelo vereinte in sich eine weibliche Sensibilität und eine herkulische Kraft, und nur er konnte die scheinbar so gegensätzlichen Ansprüche miteinander versöhnen: die Schönheit der jungen Epheben und den Glauben, der zum Himmel emportragen soll. Für ihn war die menschliche Schönheit, die er darstellte, unmittelbar aus der Hand des Schöpfers hervorgegangen und sollte die Seele der Sterblichen zu Gott zurückbringen. Es war Michelangelos *David*, der Hitlers Lieblingskünstler Arno Breker dazu inspirierte, die öffentlichen Plätze und Gebäude der Nazis mit den triumphierenden Gestalten nackter junger Männer zu garnieren. Natürlich haben solche Werke Kontroversen ausgelöst, aber auch Bewunderung. Der Krieger missachtet bewusst die Frau und idealisiert die männliche Kameraderie – ganz in der Tradition des alten Sparta.

◄ *Scene in a Brothel* (detail), late 19th century, China

Im Jahr 1948 schlug der „Kinsey-Report" wie eine Bombe ein: Darin konnte man lesen, dass 37 Prozent der männlichen Gesamtbevölkerung, das sind zwei von fünf Männern, homosexuelle Erfahrungen gemacht hatten. Der spektakuläre Selbstmord des japanischen Schriftstellers Yukio Mishima im Jahr 1970 und der Aufsehen erregende Mord an Pasolini im Jahr 1975 bedeuteten das Ende für die homoerotische Kunst. Jean Genet gab das Schreiben auf: Wofür sollte er weiter skandalöse Dinge schreiben, wenn die Welt mittlerweile dem Skandal applaudierte? Der Papst verhielt sich weiterhin als Rufer in der Wüste, während die gleichgeschlechtliche Ehe legitimiert wurde, homosexuelle Paare Kinder adoptierten und zunehmend verbürgerlichten. Die Homosexualität als Ursache und Antrieb für die Kunst kennt heute keine Verbote und keine Tabus mehr, ohne die es keine wirkliche Kreativität geben kann. Was ist seit Francis Bacon und Andy Warhol aus der homosexuellen Kunst geworden? Sie scheint sich auf die Fotografie zurückgezogen zu haben, wie George Platt-Lynes, Minor White oder Robert Mapplethorpe bezeugen, dessen Aktfiguren, die aus demselben Marmor geschnitten zu sein scheinen wie die antiken Skulpturen, immer noch für Skandale sorgen. Man hat jedoch den Eindruck, dass der Wechsel von der Unterdrückung in die Banalisierung die Kreativität getötet hat: Es ist vorbei mit dem „Gay Pride", das ist zwar besser für die Sitten, aber umso schlechter für die Kunst.

▶ **Suzuki Harunobu** *Shunga* (detail). Print, c. 1750. London, Victoria and Albert Museum

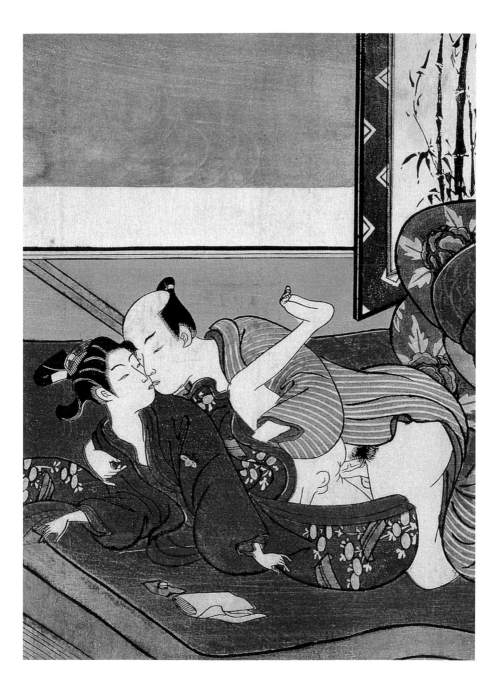

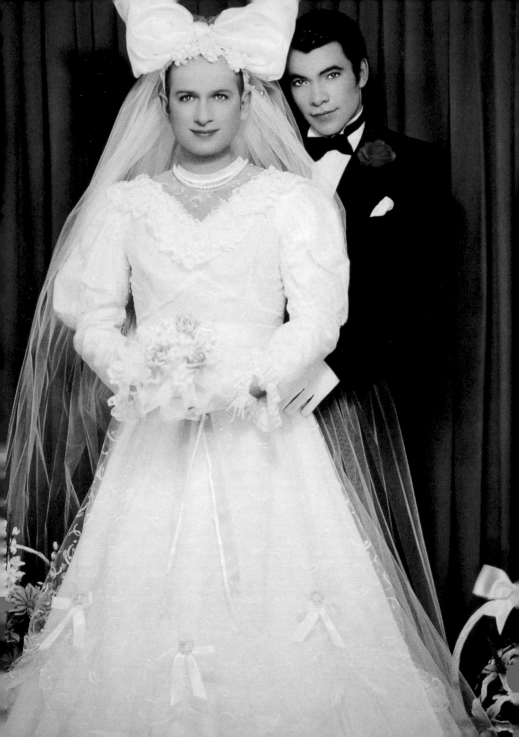

Priape et Adonis

Baudelaire conseillait : « Ne médisez jamais de la grande nature, et si elle vous a adjugé une maîtresse sans gorge, dites : Je possède un ami avec des hanches. Et allez au temple rendre grâce aux dieux. » Les héros de l'histoire de l'art homo forment un couple. Il y a d'un côté Priape, dieu des Jardins, des Vignes, de la Génération ; fils de Dionysos et d'Aphrodite ou d'une nymphe. Il personnifie la virilité. De l'autre, il y a Adonis, divinité phénicienne, jeune homme de Byblos d'une grande beauté, qui fut blessé mortellement par un sanglier et que Vénus changea en anémone. Il est symbole de la beauté efféminée. C'est entre ces deux êtres, complémentaires et interchangeables, qu'hier comme aujourd'hui Eros vient le plus souvent jouer de son arc. Mais rendons d'abord à César ce qui est à César. Hollywood l'a représenté le plus souvent amoureux de Cléopâtre. Mais Cicéron, qui l'a bien connu, plus fidèle à la vérité, parle dans ses lettres de sa fameuse aventure avec Nicomède, roi de Bithynie, qui lui valut d'être interpellé à la tribune du Sénat par Suétone qui le traita de « femme de tous les hommes, mari de toutes les femmes », tandis que d'autres sénateurs faisaient chorus, l'apostrophant en termes choisis, allant de « concubine d'un roi » à « Lupanar de Nicomède », ou « prostituée bithynienne ». En ce temps-là, on n'avait pas peur des mots, et d'ailleurs César fit front : « D'accord, je suis la femme de Nicomède, mais je connais des femmes qui sont mille fois plus énergiques que vous. »

L'imagerie homosexuelle est très pauvre, compte tenu des interdits et des tabous, et l'on ne peut parler d'Age d'Or de la pédérastie que s'agissant de la Grèce ou de l'Empire romain. On pourra toutefois, au fil des siècles, en discerner la face cachée, lorsqu'un artiste, par exemple Ingres ou David, sans le faire peut-être consciemment, en exaltera l'aspect viril ou efféminé au détour d'un nu. Platon enseignait que « jadis la nature n'était pas ce qu'elle est aujourd'hui ; elle était bien différente. L'humanité se divisait en trois espèces d'homme et non en deux comme présentement. Avec les sexes mâle et femelle, il en était un troisième qui participait de ces deux. L'espèce en a été détruite, et le nom seul survit. Cette espèce s'appelait alors androgyne, car son aspect et son nom rappelait à la fois le mâle et la femelle. » Toutefois on peut dire que le sage, en se tournant vers l'éphèbe, vers le jeune homme à l'âme féminine, ne recherche donc pas tant à assouvir un amour physique particulier qu'à retrouver, en matière sexuelle, et sur le plan de la sensibilité aussi, une espèce d'Age d'Or. L'Age d'Or n'a malheureusement jamais été retrouvé. Et depuis, l'être qui tend à l'androgynat est sur l'un ou l'autre des deux versants, criant, sans

espoir, vers l'unité. Mais il peut, cependant, se trouver très proche de la ligne de faîte. Ainsi, par exemple, de César ou de Michel-Ange.

Les Grecs, à l'image des dieux qu'ils s'étaient inventés, sacrifiaient largement à l'amour uranien, par vertu, par refus de se laisser amollir par les femmes qu'ils trouvaient creuses et obscures comme les cavernes qui mènent à l'Enfer. Sophocle, Euripide, Phidias étaient les grands prêtres de ce credo et des poètes comme Pindare, Théocrite, évoquaient tantôt l'Eros céleste, tantôt l'Eros vulgaire. Les bergers de leurs Idylles ne mâchaient pas leurs mots : « Lorsque je t'empalais, tu n'étais pas si fier ! » dit Comatus à son ami Lacon. Ils évoquaient l'amour fou d'Hercule pour l'enfant Hylas « aux longs cheveux bouclés ». Plutarque parle aussi des mignons de Démétrius dont la *Victoire de Samothrace* rappelle le souvenir : « Un jour Démétrius était malade. Son père alla le voir et croisa un beau jeune homme qui sortait. Démétrius le rassura : ‹ La fièvre vient de me quitter, mon père… ›. ‹ Je le sais, mon fils, je l'ai croisé en entrant ›. » A Rome, Sénèque résume ainsi l'éthique en vogue : « La passivité sexuelle est un crime pour l'homme libre, une obligation pour l'esclave, un service pour l'affranchi. » Cette règle était encouragée par les empereurs eux-mêmes, de César à Tibère, dont les excès défrayaient la chronique. De Caligula, prince de la dépravation, qui épousa son cheval, à Néron qui fit châtrer son esclave Sporus avant de le prendre pour femme. Sous son règne, le charmant Pétrone raconte, dans son *Satyricon*, les aventures scandaleuses d'Encolpe et de Giton, dont le nom, depuis, est devenu synonyme de « mignon entretenu servant au plaisir ». Les sculpteurs ont dressé d'innombrables statues à Antinoüs, jeune Grec de Bithynie d'une grande beauté, favori de l'empereur Hadrien, qui le plaça au rang des dieux et fit reproduire son image par les artistes les plus fameux. Antinoüs inspira ainsi de nombreuses statues antiques et est devenu aujourd'hui l'icône Gay par excellence. Le culte du corps et de la beauté virile que représentent les Kourï archaïques rejoint celui des athlètes et des dieux de Myron, de Praxitèle, de Polyclète, de Lysippe – le choix est vaste… Les Césars étaient loin d'être tous efféminés. Ils pouvaient être aussi des soldats virils, comme Galba ou Auguste qui donna son nom à son siècle. Les moralistes oublient toujours que *L'Iliade* – que l'on enseigne aux écoliers – est basée sur l'amour d'Achille pour Patrocle. Le mot de Frédéric II est précis comme un rapport militaire : « L'amour est un dieu perfide. Quand on lui résiste en face, il se retourne. »

Au Moyen Age, mauvaise époque pour les sodomites, on les brûlait sur le moindre soupçon. Lors de son fameux procès, Gilles de Rais, dit Barbe Bleue (1440), avoua : « C'est en lisant un livre orné de belles images sur la vie et les mœurs des Césars par Suétonius que je fus inspiré par les débordements de Tibérius, Caracalla et autres Césars. »

► Andy Warhol *Golden Nude*, 1957
Decorated with gold leaf, this work of his pre-Pop style
is typical of the artist when he was still only a fashion illustrator

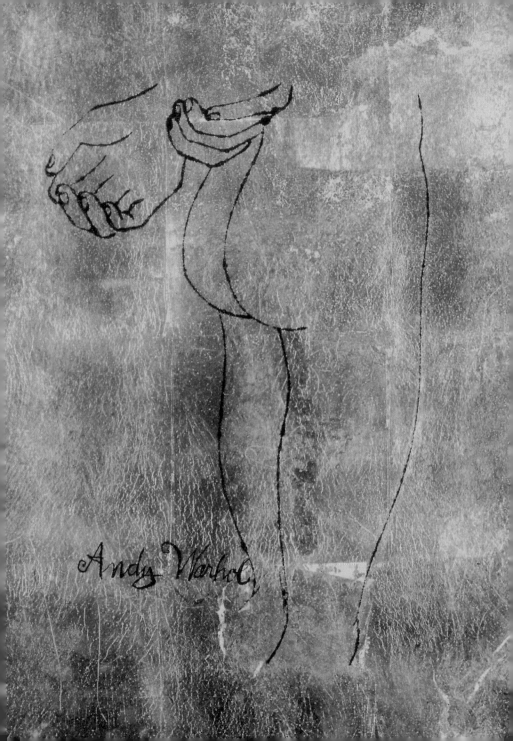

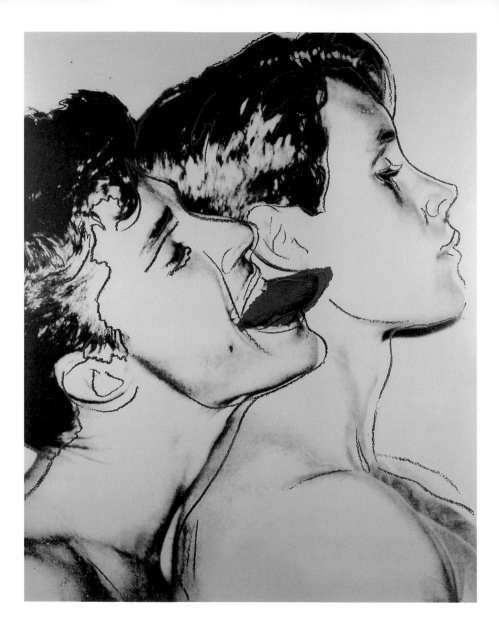

Andy Warhol *Querelle.* Colour silkscreen print, 1982. Private collection

La Renaissance, en revanche, qui révolutionna l'histoire de l'art, fut engendrée par de grands homosexuels, reconnus et respectés comme tels, de Botticelli à Raphaël. Léonard de Vinci fut impliqué, tout jeune, dans une affaire de pédérastie, et Giovanni Antonio Bazzi, dit Il Sodoma, portait fièrement son surnom. Caravage perdit des fortunes et passa de prison en prison, car il ne pouvait résister à ses pulsions et violait les adolescents qu'il peignait, fussent-ils nobles. A la même époque, Shakespeare adressait des sonnets amoureux à un jeune homme de ses amis, tandis que Michel-Ange couvrait le plafond de la chapelle Sixtine d'Ignudi, le membre viril à l'air, en adressant, lui aussi, des poèmes brûlants d'amour au beau Cavalieri qu'il aima tout sa vie. Seul un Michel-Ange, aux aspirations et aux dons alliant une sensibilité féminine à une force digne d'Hercule, pouvait concilier des aspirations apparemment opposées : la beauté des jeunes éphèbes et la foi qui fait gagner le ciel. Pour lui, la beauté humaine qu'il représentait était sortie tout droit de la main du Créateur et devait ramener l'âme des mortels au divin. C'est en contemplant son *David*, que l'artiste préféré du Führer, Arno Breker, orna les places publiques et les édifices nazis de jeunes hommes nus et triomphants. De telles œuvres excitent sans doute la controverse, mais aussi l'admiration. Le guerrier méprise volontiers la femme et idéalise la camaraderie masculine – vieille tradition spartiate…

La bombe du Rapport Kinsey explosa en 1948 : on y apprenait que 37% de toute la population masculine, soit deux hommes sur cinq, avaient des expériences homosexuelles. Le suicide grandiose de Mishima en 1970, l'assassinat retentissant de Pasolini en 1975, marquèrent une fin pour l'art homo. Jean Genet cessa d'écrire : à quoi bon rester scandaleux dans un monde qui applaudissait maintenant au scandale ? Le pape continuait à crier dans le désert, pendant qu'on se mariait entre hommes, qu'on adoptait des enfants, qu'on s'embourgeoisait. Ferment et levain d'œuvres d'art, l'homosexualité n'a plus aujourd'hui d'interdits ni de tabous sans lesquels il ne peut y avoir de véritable création. Depuis Bacon et Warhol qu'est devenu l'art homo ? Il semble s'être réfugié dans la photographie, celle d'un George Platt Lynes, d'un Minor White ou d'un Robert Mapplethorpe dont les nus, qui semblent du même marbre que les sculptures antiques, font encore quelque peu scandale. Mais on a l'impression que le changement de la répression en banalisation a tué la création : la Gay Pride est passée par là – tant mieux pour les mœurs, tant pis pour les arts.

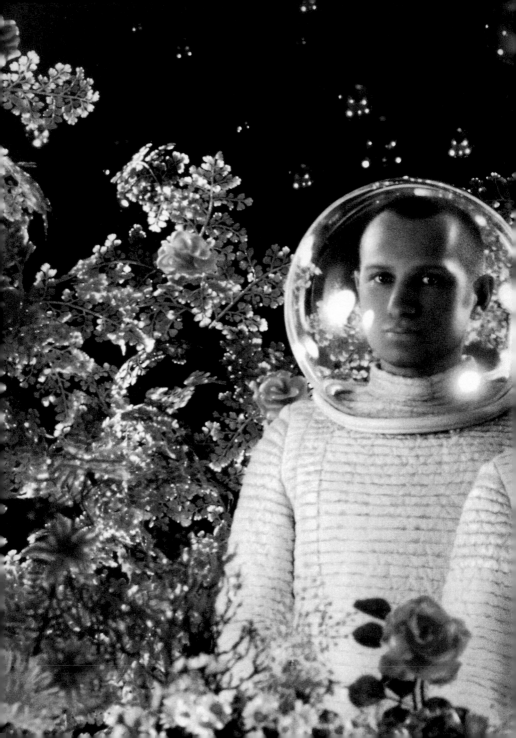

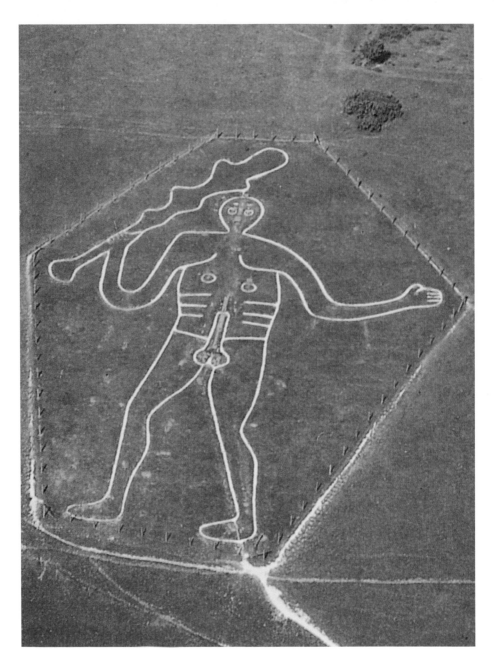

The Cerne Abbas Giant. Phallic figure carved in the chalk
of a hillside near Dorchester, England

The King Phallus

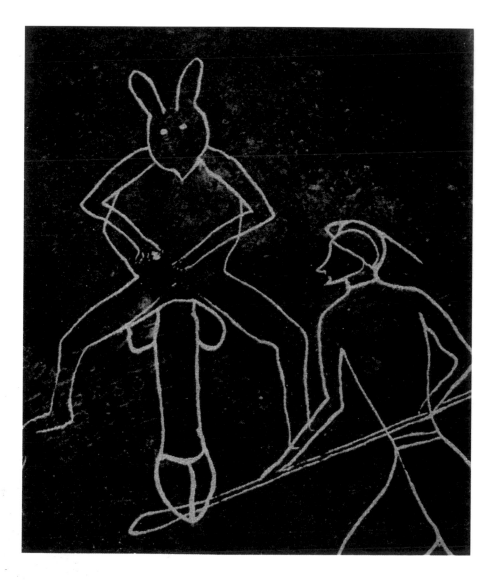

Rock drawings, 5000 BC. Ti-n-Lalan, Fezzan, Libya

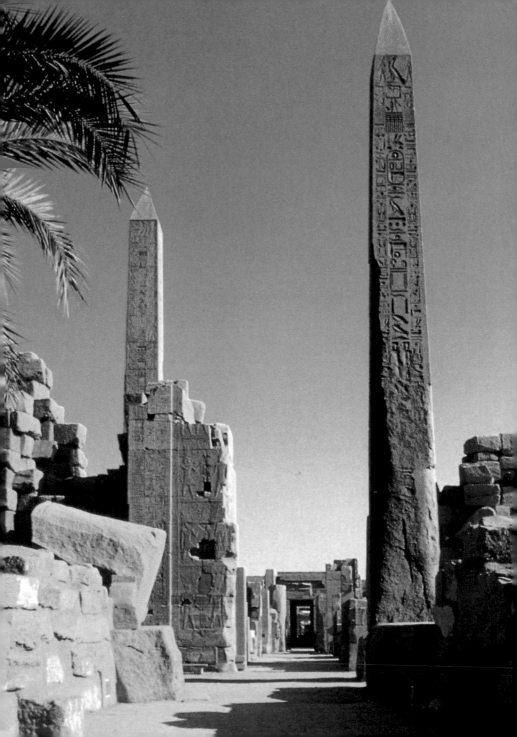

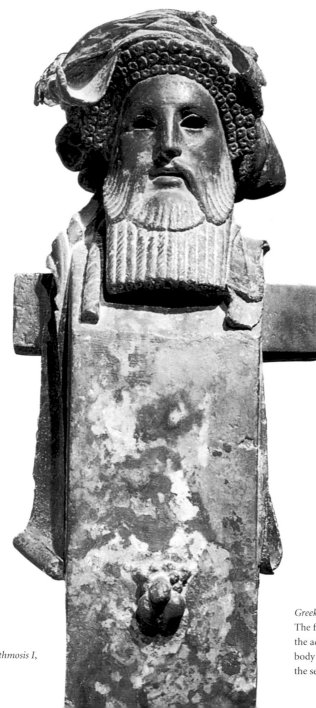

◄ *Obelisk of Tuthmosis I*,
Karnak, Egypt

Greek Hermes, c. 100 BC.
The figure is reduced to
the active parts of the
body – the head and
the sexual organs

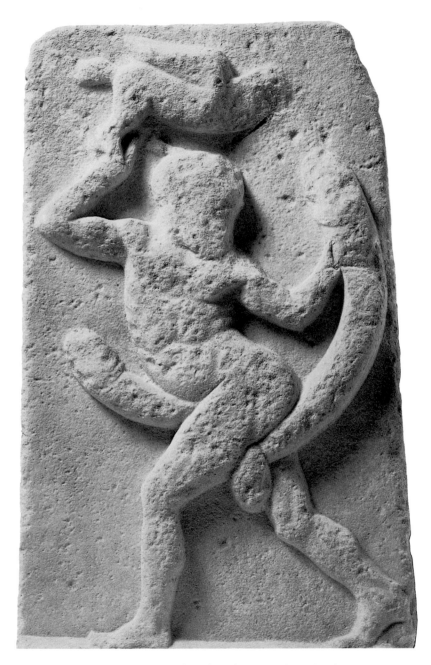

Triphallic Priapus, personifying the male organ as the carrier of sperm.
Terracotta statue, 2^nd century BC. Chalcis, Archaeological Museum

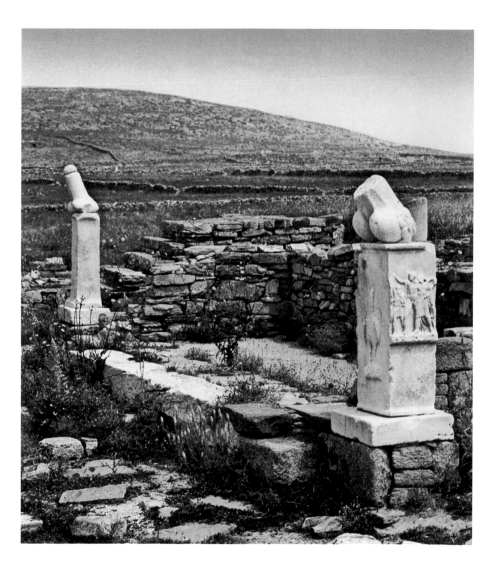

Monumental sculptures in the form of an erect phallus,
3rd century BC, Island of Delos

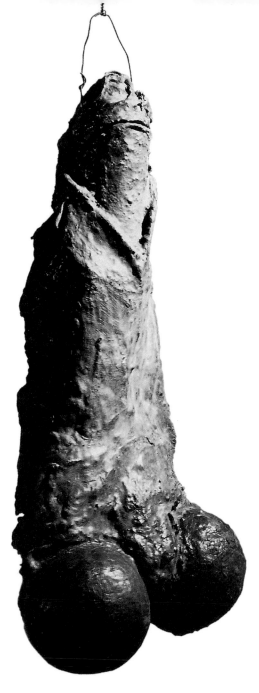

*Phallic Corinthian
ceramic vase used
as an ex-voto,
6th century BC.
London, British
Museum*

Louise Bourgeois
Fillette. Latex, 1968

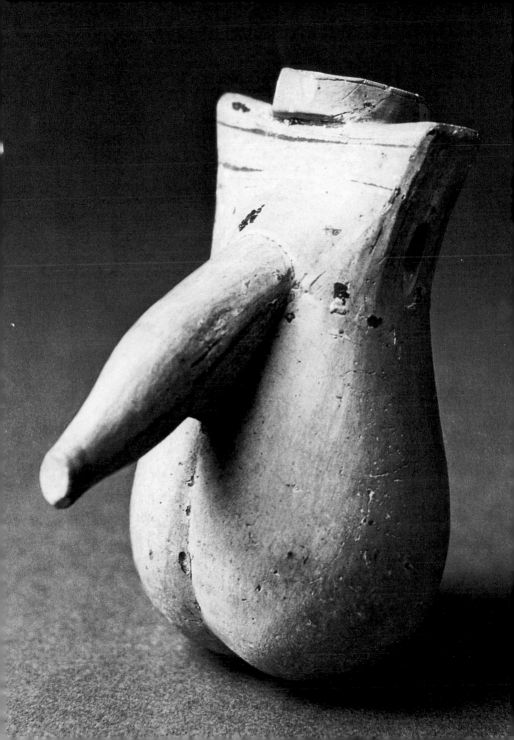

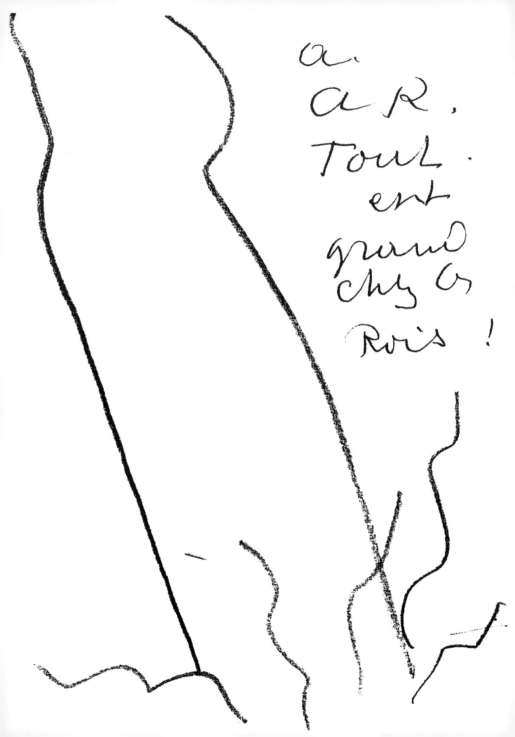

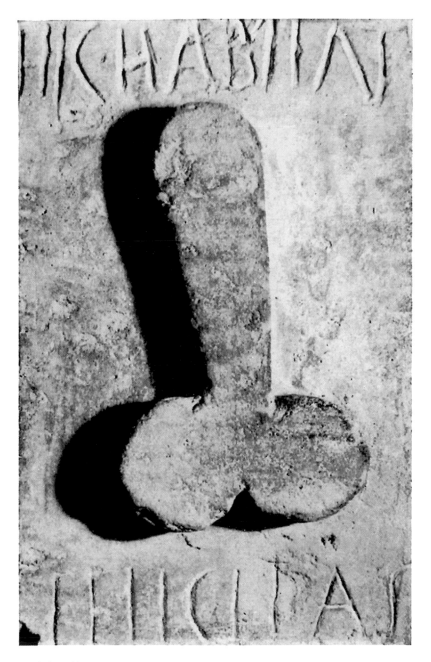

▲ *Hic habitat felicitas*, inscription on a tomb in Pompeii. Naples, National Archaeological Museum
◄ **Henri Matisse** Illustrated quote from Bossuet, in a letter to André Rouveyre, 1952 35

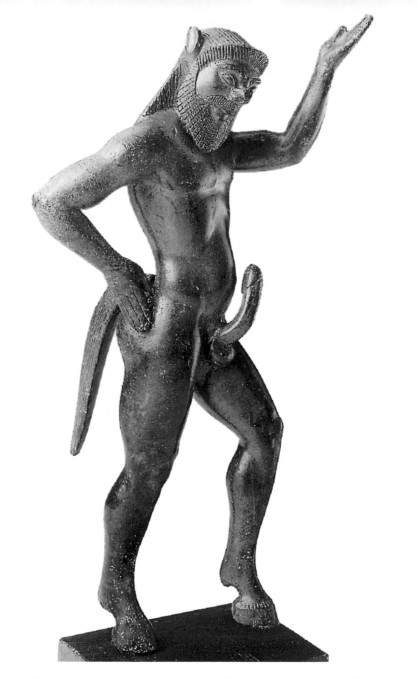

▲ *Silenus dancing*. Bronze, Corinth, 535–525 BC. Athens, National Archaeological Museum
► *Satyr*, 5th century BC. Greece

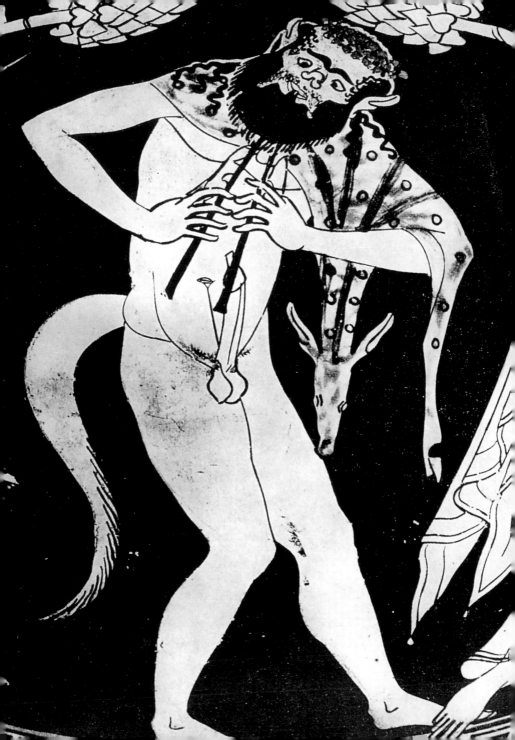

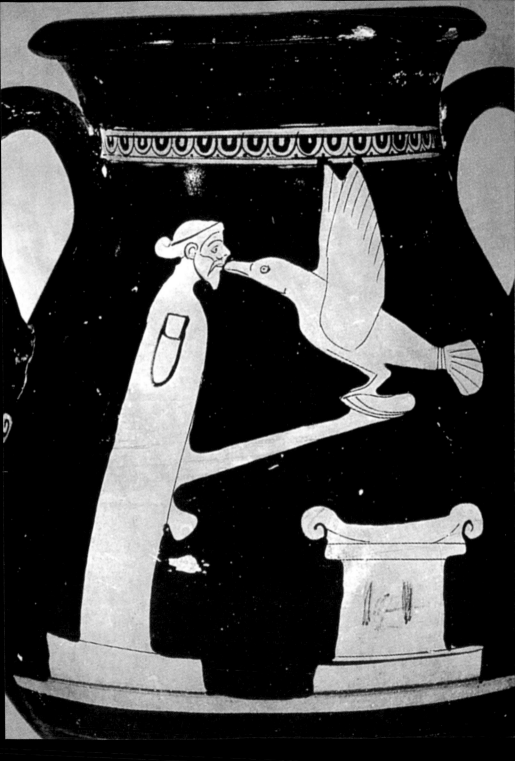

▲ Michelangelo *Scherzo*, c. 1512
◄ *Hermes with a bird perched on his phallus above an altar.* 5th century BC. Greece

39

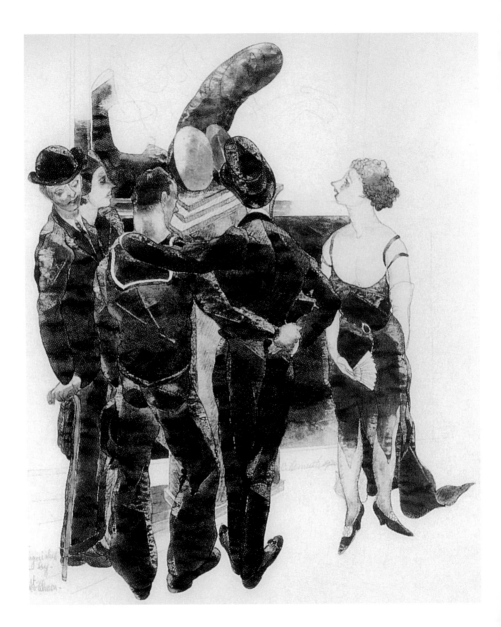

▲ **Charles Demuth** *Distinguished Air*, 1930. New York, Whitney Museum of American Art

▶ **Constantin Brancusi** *Princess X*, 1916. Matisse referred to this bronze as "the phallus"

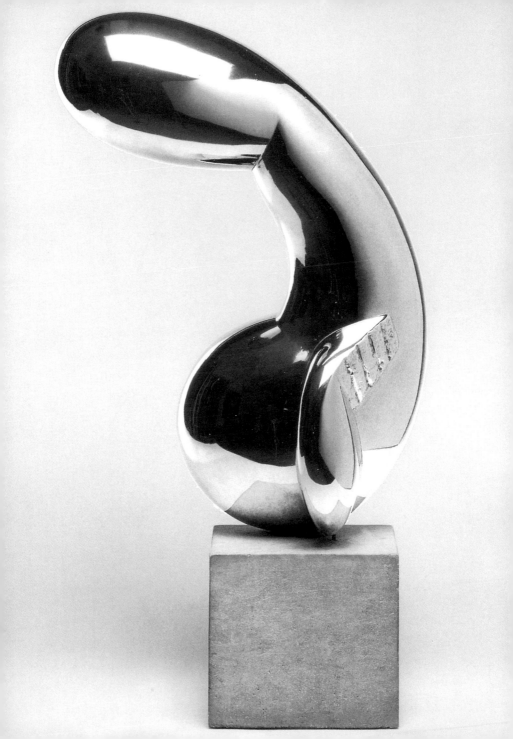

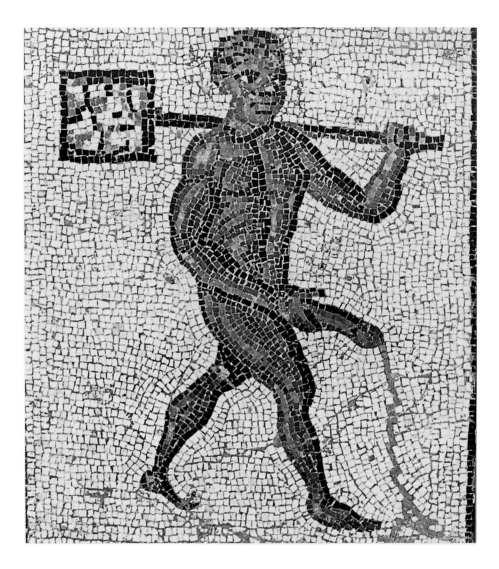

Erotic mosaic, late 1st century. Timgad, Algeria

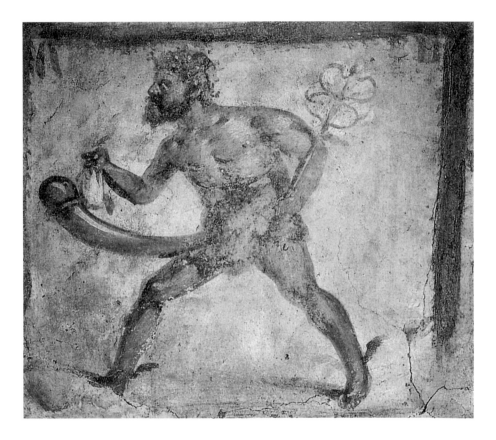

The divine phallus, 1st century. Pompeii

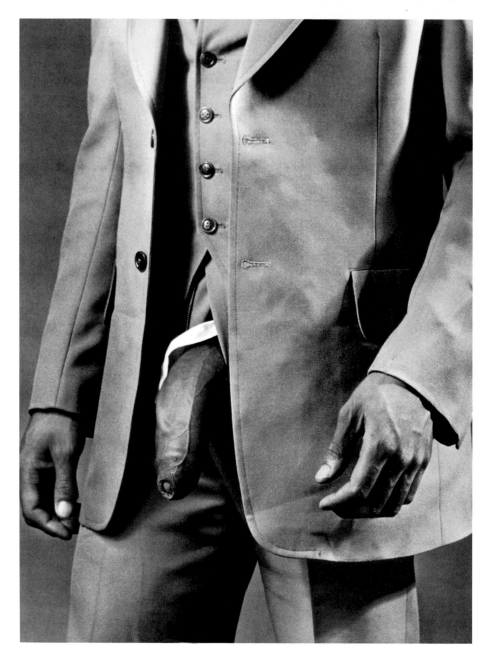

Robert Mapplethorpe *Man in Polyester Suit*, 1980

▶ *Priapus weighing his phallus*, 1st century. Mural painting from the House of the Vetii, Pompeii

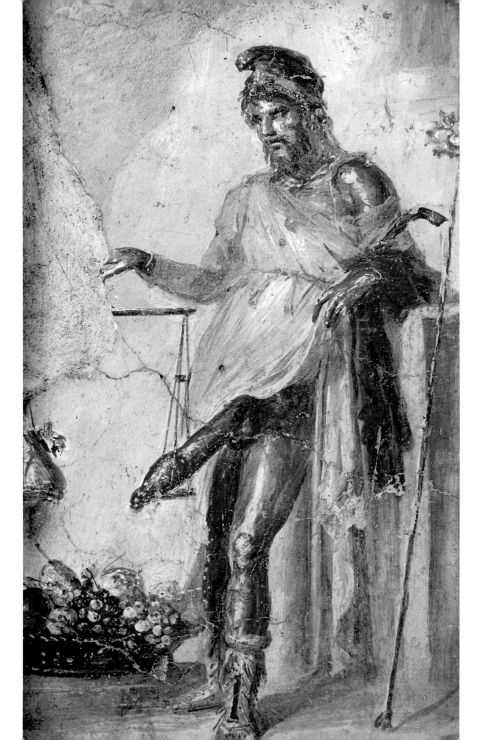

Eugène Le Poitevin *Living Phenomenon.* From the sequence *Erotic Devilries*, 1832

Figure of Harpocrates riding on his phallus. Delos, Hellenistic period.
Archaeological Museum of Mykonos

48

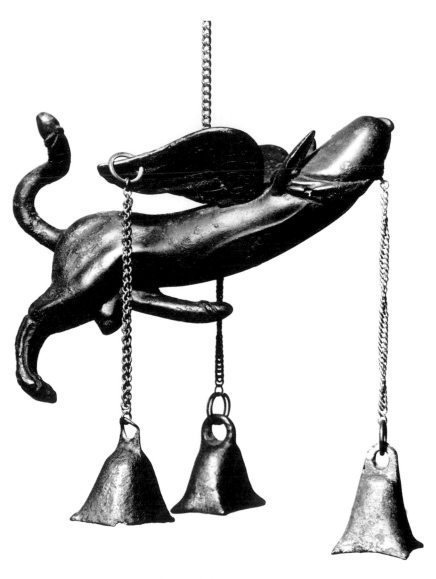

▲ Apotropaic tintinnabulum,
ornamental quadruple phallus with bells. Roman, 1st century BC.
◄ Eugène Le Poitevin *Bitch of a Prick*. From the sequence *Erotic Devilries*, 1832

► *Marble relief representing two phalluses.* Delos, House of Phourni, Hellenistic period. Archaeological Museum of Delos

▲ **Vivant Denon** *Le Phallus Gigantesque*, 1793. Vivant Denon was the first director of the Louvre, and accompanied Napoleon on his Egyptian adventure

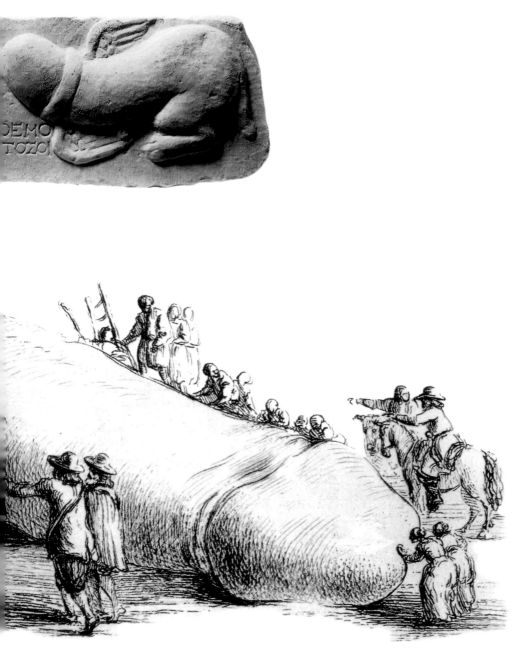

This etching is a parody of the conventional image
of a whale washed up on a beach

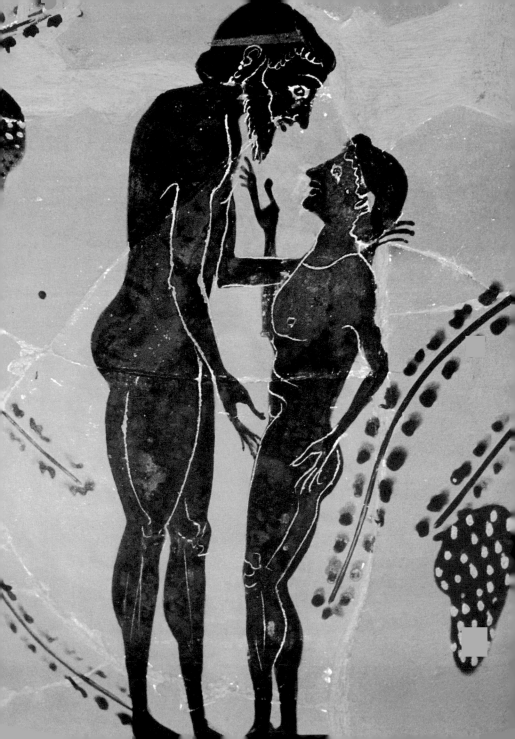

Greek Eros

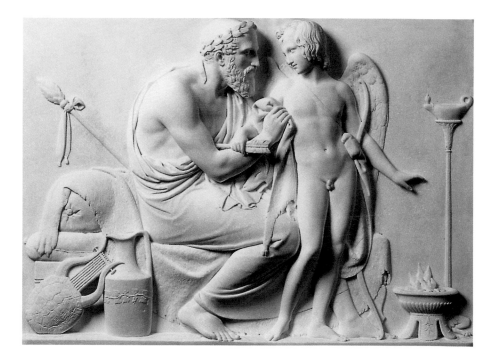

▲ **Bertel Thorvaldsen** *Anacreon and Cupid.* Marble, 1823. Copenhagen,
Thorvaldsen Museum
◄ *Man and Ephebe*, late 6ᵗʰ century BC. Greece

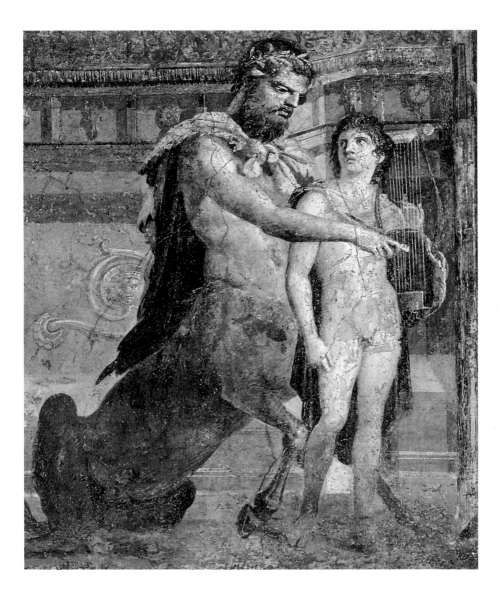

Achilles and Chiron. Fresco from the basilica of Herculaneum, 1st century BC.
Naples, National Archaeological Museum

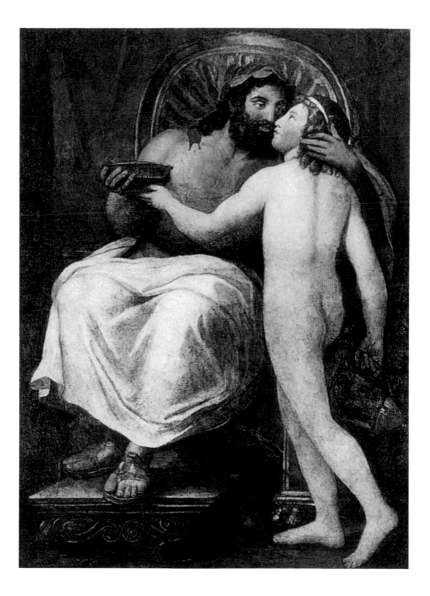

Anton Raphael Mengs *Jupiter and Ganymede.* Fresco, 1758–59.
Rome, National Gallery of Antique Art, Barberini-Corsini Palaces

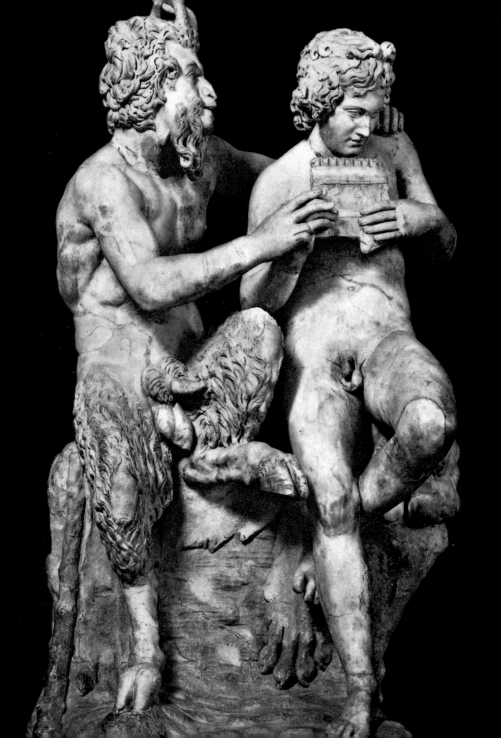

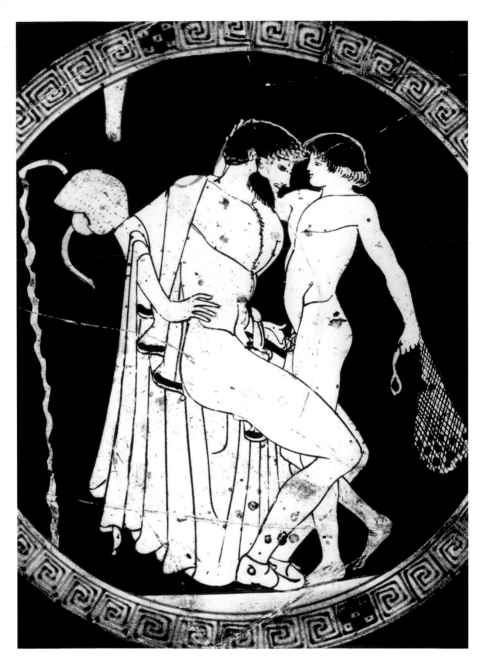

▲ *Man fondling a Young Boy.* Red-figure bowl, 500–475 BC. Greece
◄ **Heliodorus** *Pan and Daphne.* Naples, National Archaeological Museum

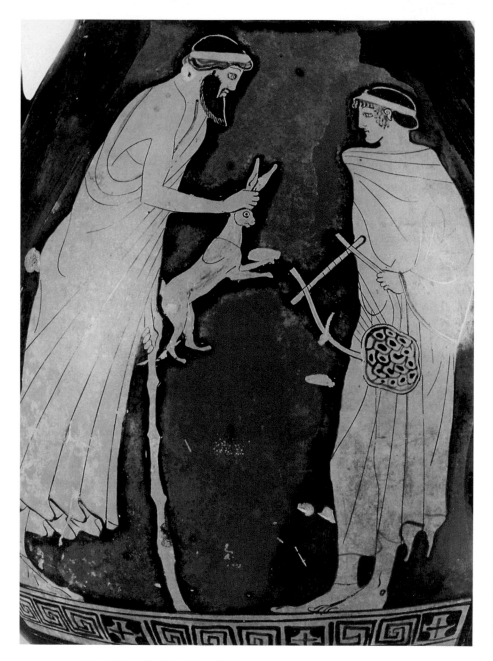

▲ *Man offering a hare* (a traditional gift between lovers) to the young boy he desires.
Attic red-figure pelike, c. 460 BC. Athens, National Archaeological Museum

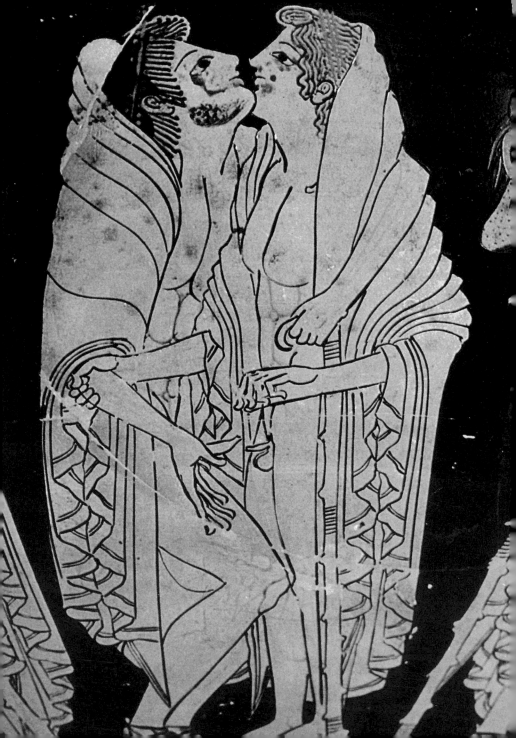

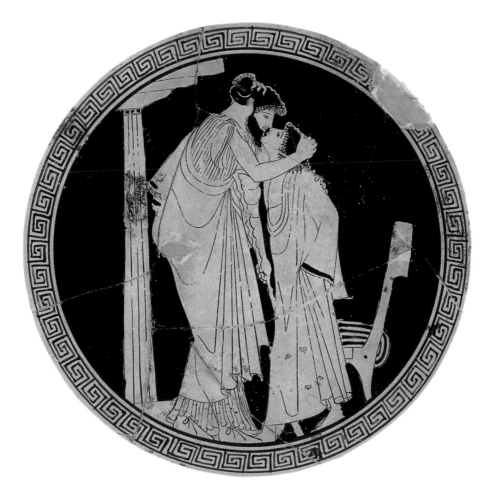

▲ *Man kissing an Ephebe.* Attic bowl, 5th century BC. Paris, Louvre
◄ *Man and young boy,* 525 BC. Boston, Museum of Art
◄◄ *Two lovers competing for the favours of a young boy.* Pelike, 470 BC. 61

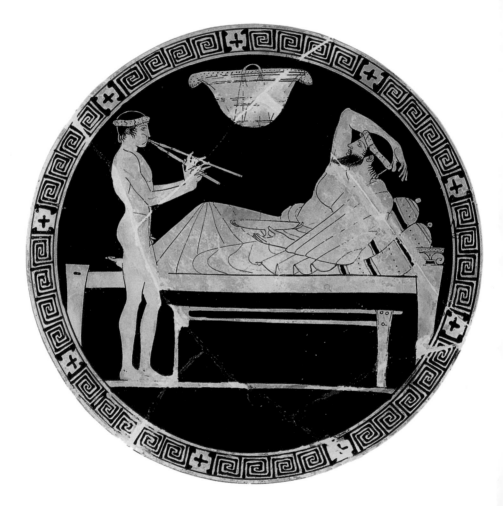

Picture by **Enaion**: *Esaste and a young musician.*

Red-figure plate, c. 460 BC. Paris, Louvre

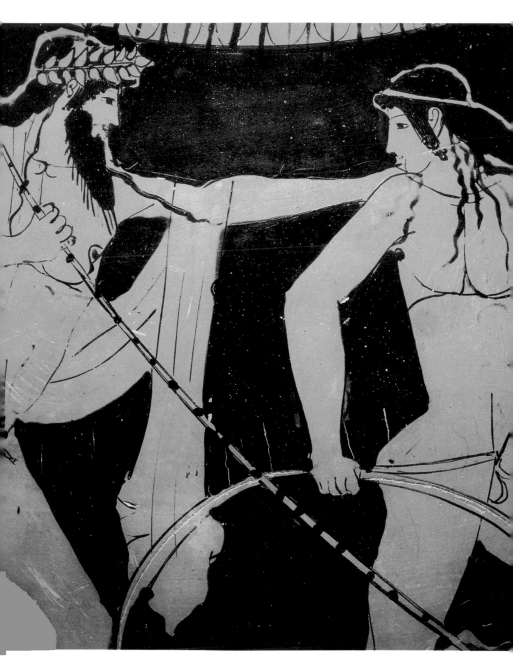

Zeus abducting Ganymede. Red-figure pelike, c. 470 BC.
Athens, National Archaeological Museum

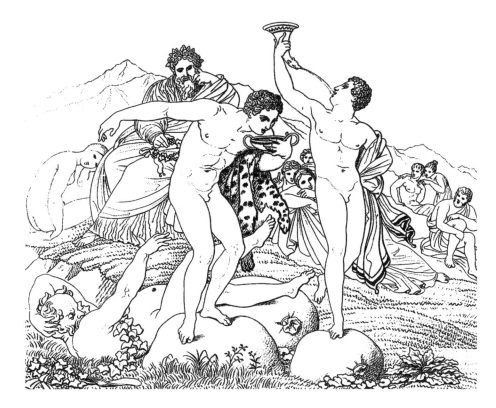

Anne-Louis Girodet de Roucy-Trioson Two illustrations
for the *Odes of Anacreon*, 19th century. Paris, National Library

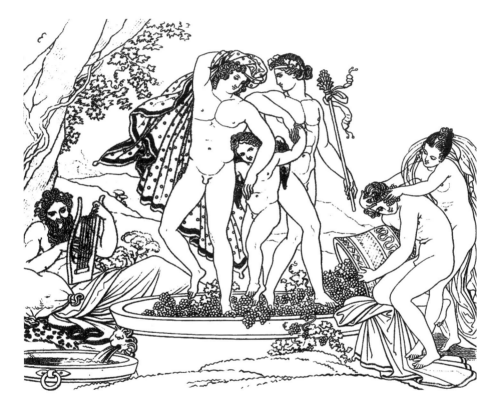

When someone asked Anacreon why his poems were always
about children and not gods, he replied: "That is because children are our gods."

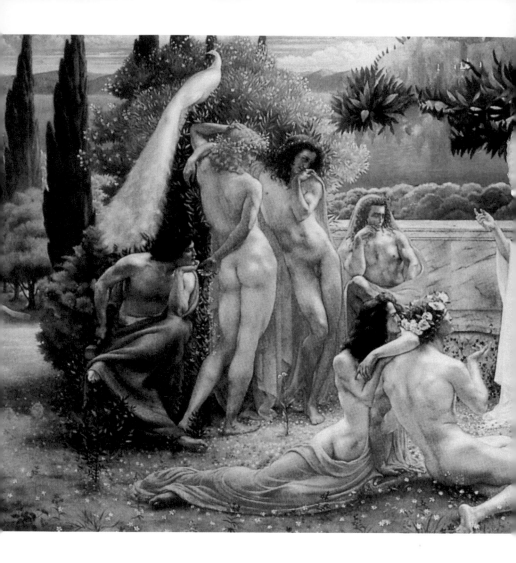

Jean Delville *Plato's Academy*, 1818. Paris, Museum Orsay

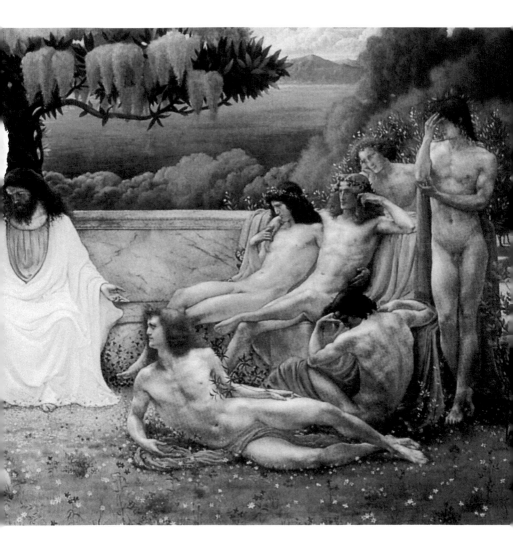

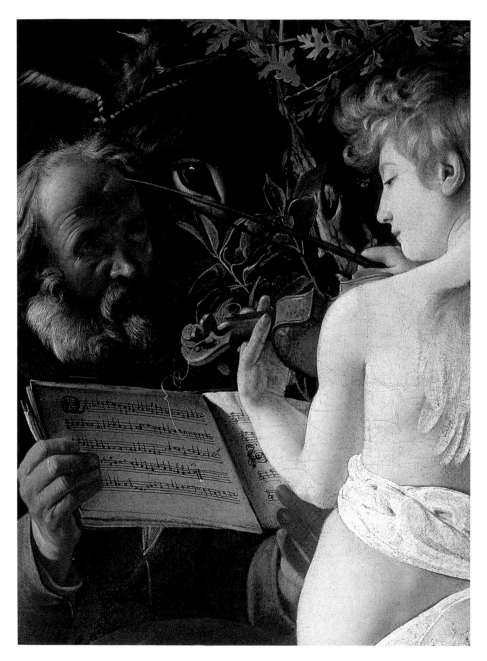

▲ **Caravaggio** *The Rest on the Flight to Egypt* (detail), c. 1596–1597. Rome, Doria Pamphili Gallery

▶ **Workshop of Raphael** *Jupiter and Ganymede*, 1541. Paris, Louvre

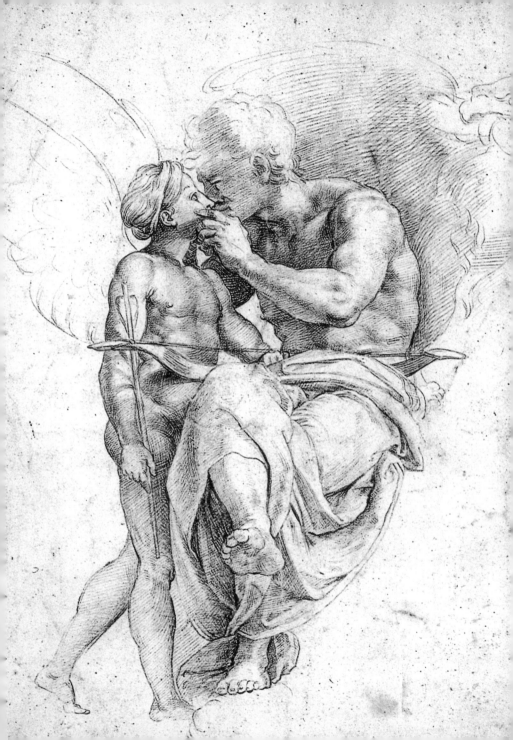

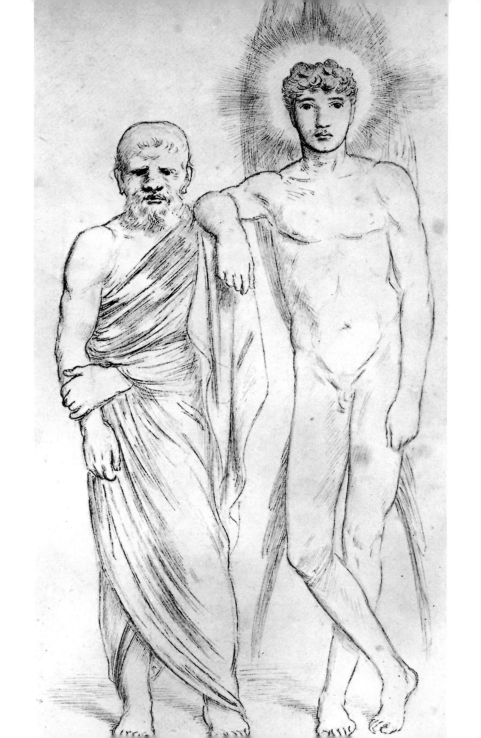

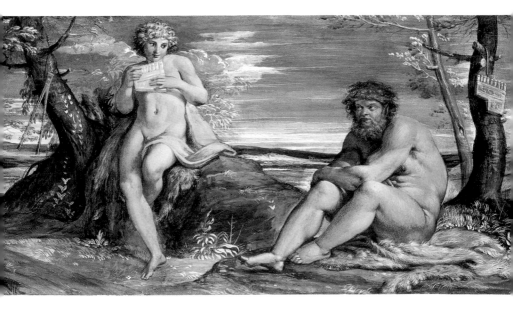

▲ **Annibale Carracci** *The Flute Lesson (or, Marsyas and Olympus)* 1597–1600.
London, The National Gallery
◄ **Simeon Solomon** *Socrates and Agathodaemon*, 19th century.
London, Victoria and Albert Museum

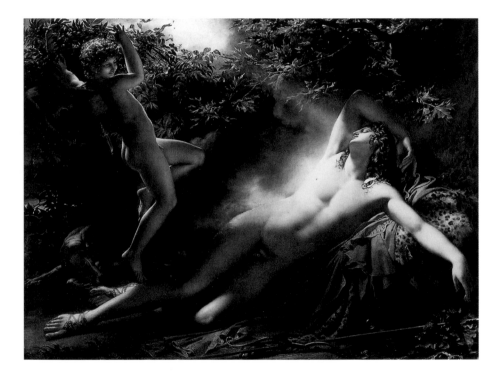

▲ Anne-Louis Girodet de Roucy-Trioson, *Endymion Asleep*, 1791. Paris, Louvre
▶ Pierre Klossowski *Pro Serena Pulchritudine Excitates Perpetuea*, 1975.
Illustration for *Histoire de Juliette II* by the Marquis de Sade

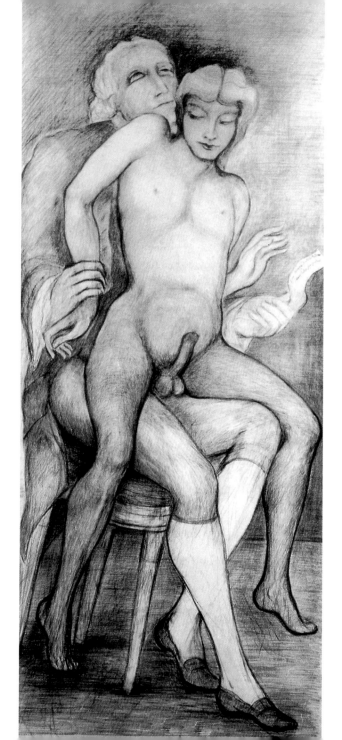

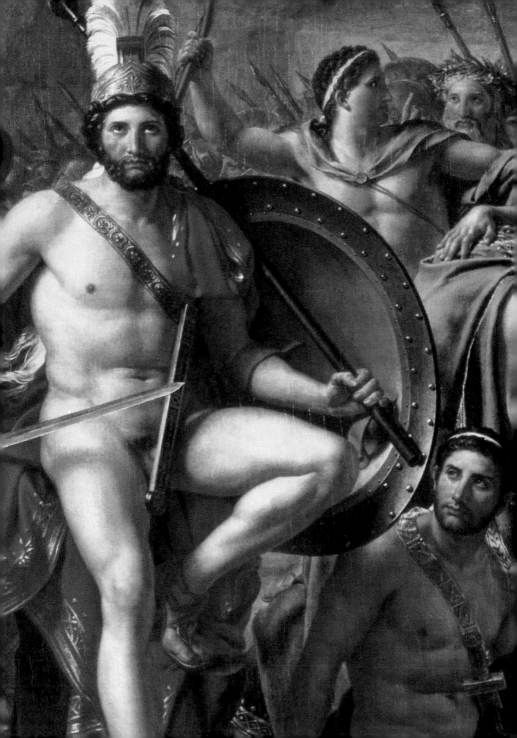

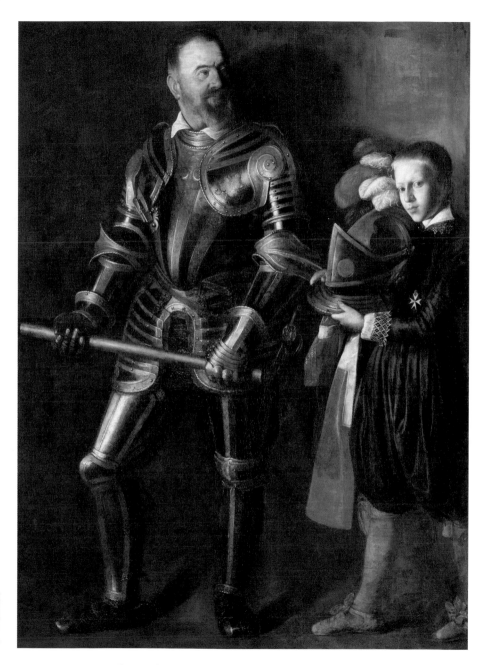

▲ Caravaggio *Portrait of Alof de Wignacourt*, c. 1608. Paris, Louvre
◀ Jacques-Louis David *Léonidas aux Thermopyles* (detail), 1800–1814. Paris, Louvre

75

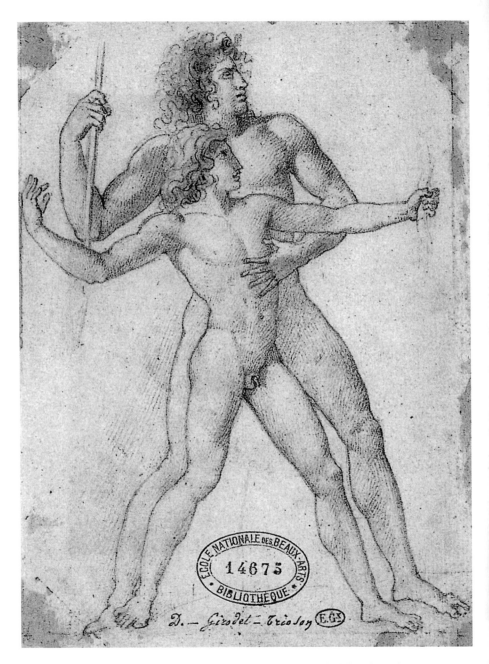

Anne-Louis Girodet de Roucy-Trioson *The Education of Achilles.* Charcoal,
late 18th century. Paris, National School of Fine Arts

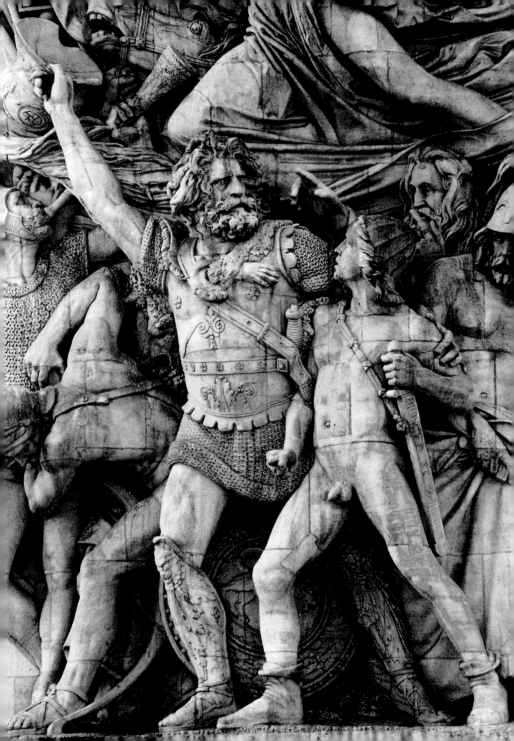

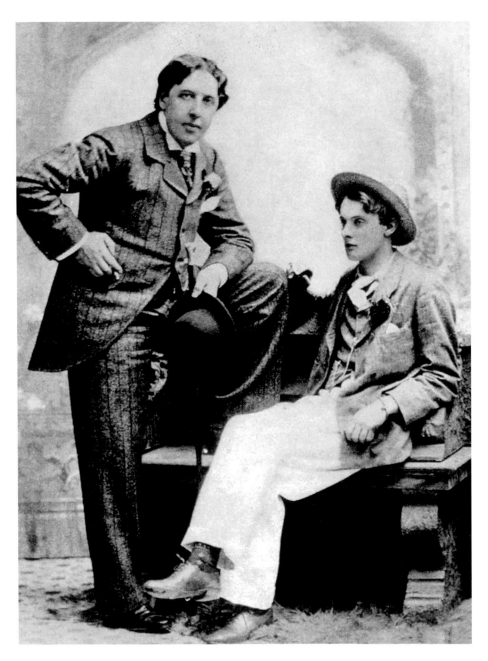

▲ Oscar Wilde accompanied by his lover "Bosie", on whose account he was sentenced to gaol in England...

◄ **François Rude** *La Marseillaise*, 1835. Detail of the Arc de Triomphe in Paris

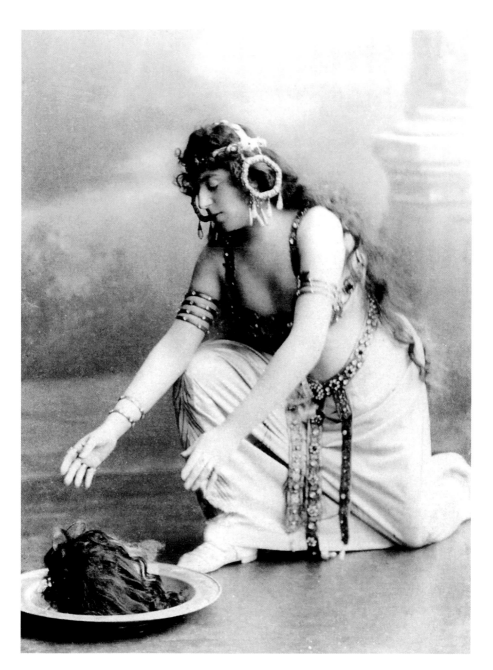

Oscar Wilde as Salome, the heroine of the play he wrote
based on the famous biblical legend

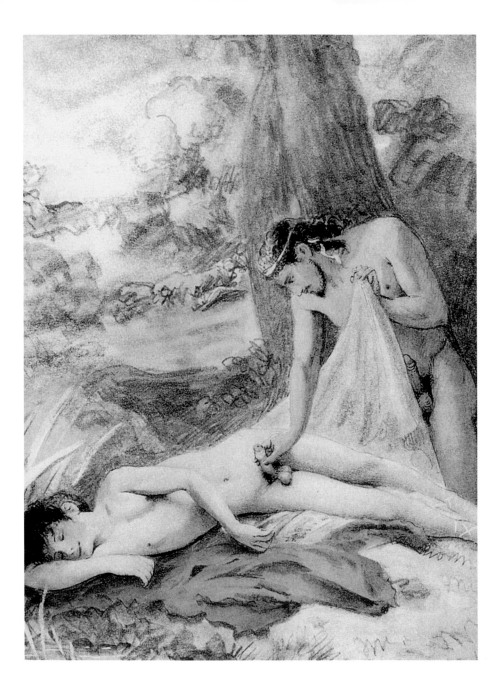

Anonymous Engraving for *Œuvres Libres* by Verlaine, 1920s

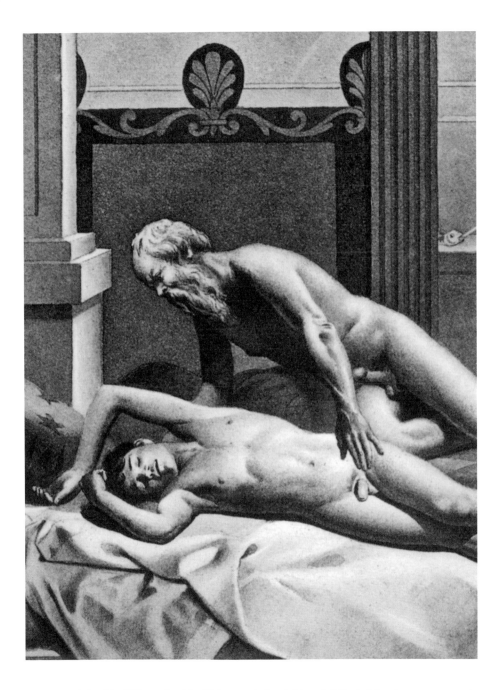

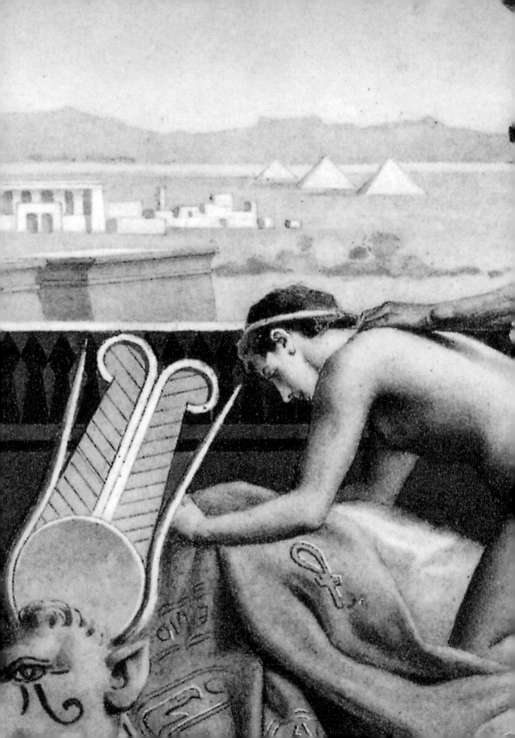

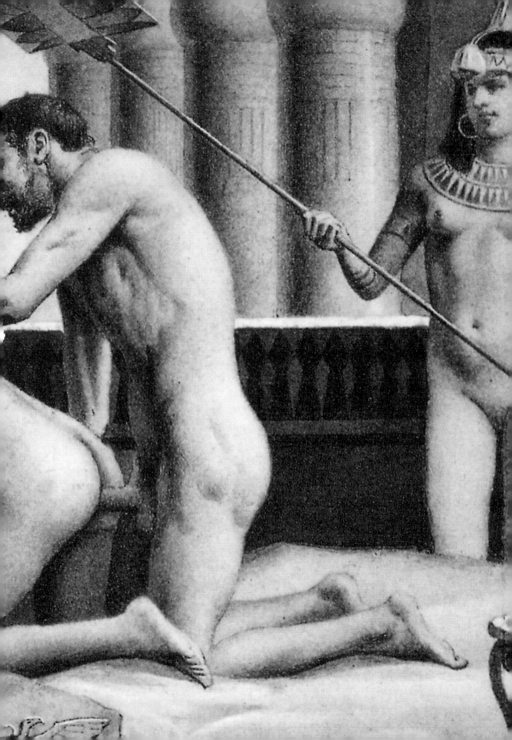

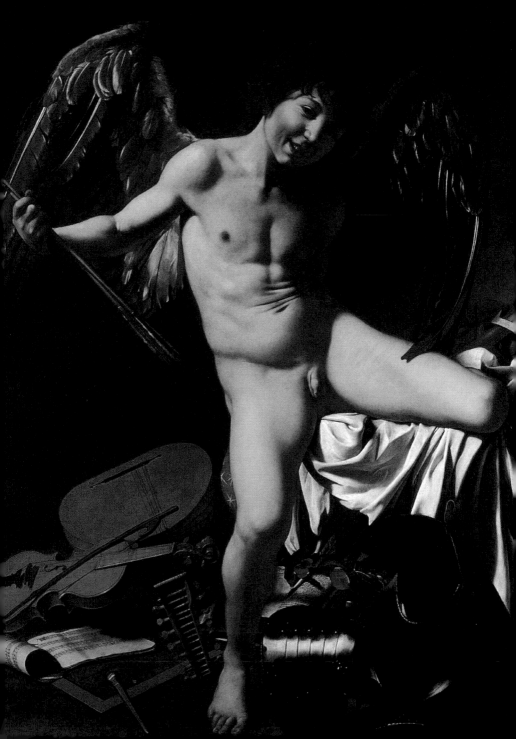

Ave Caesar

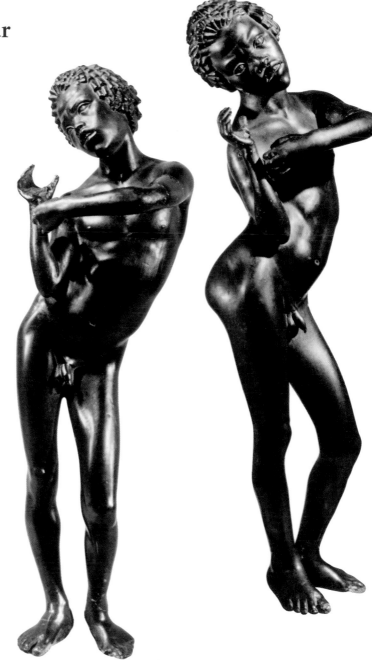

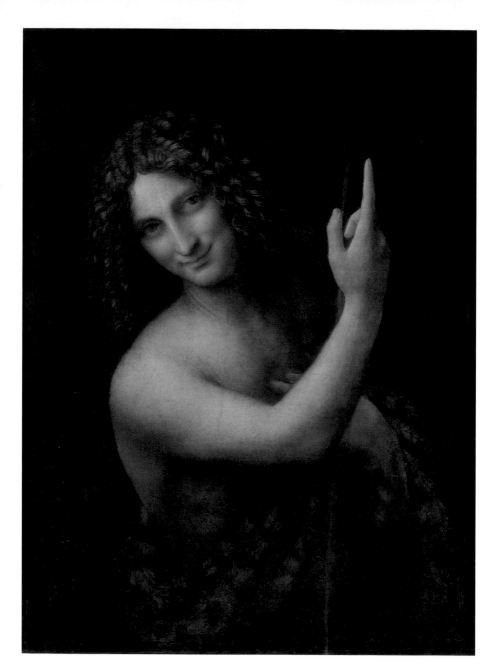

▲ **Leonardo da Vinci** *St. John the Baptist,* c. 1513–1516. Paris, Louvre
▶ **Guido Reni** *St. John the Baptist,* c. 1670. London, Dulwich Picture Gallery

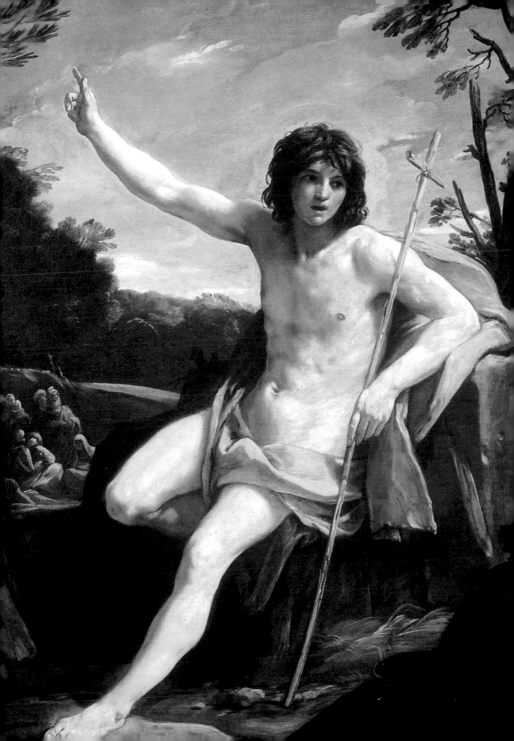

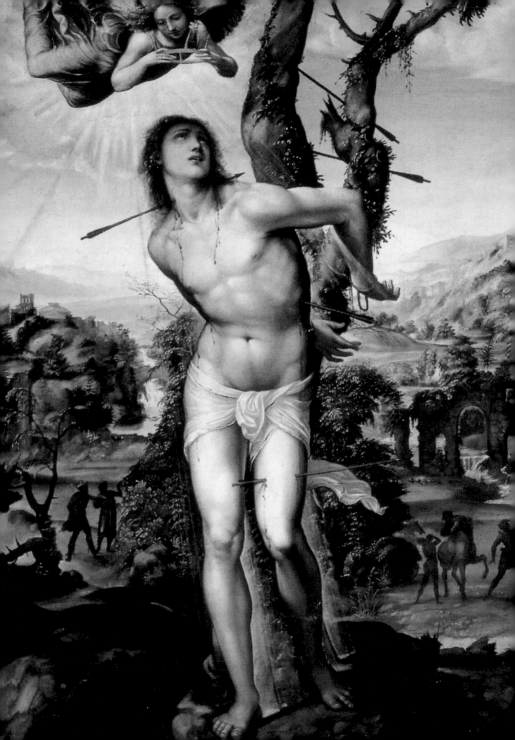

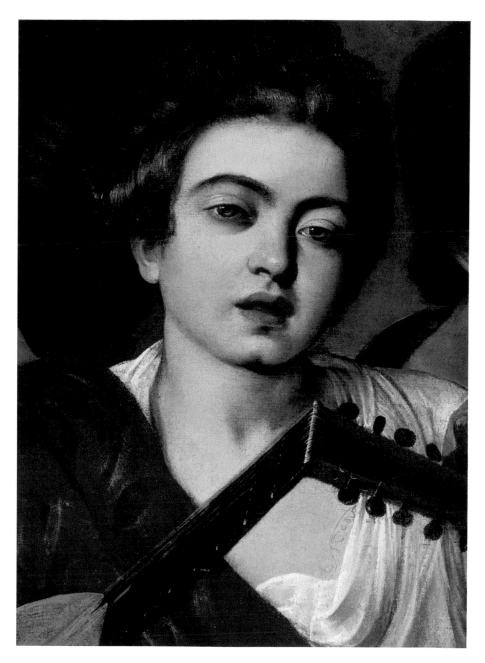

▲ **Caravaggio** *The Musicians* (detail), c. 1595–1596. New York, Metropolitan Museum of Art
◄ **Il Sodoma** (Giovanni Antonio Bazzi, known as) *St. Sebastian*, 1525. Florence, Pitti Palace 89

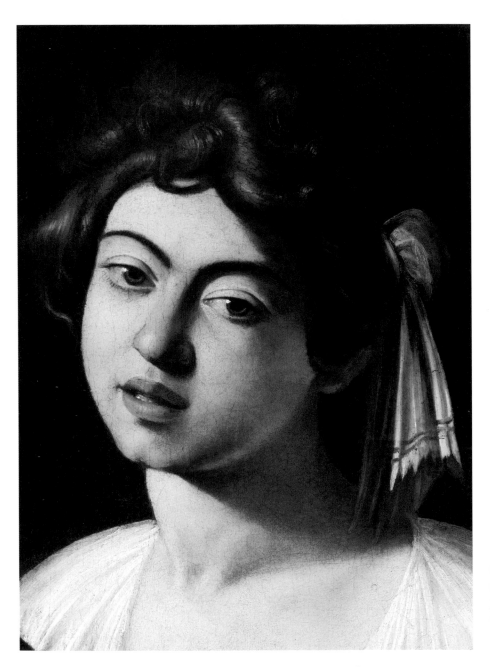

▲ **Caravaggio** *The Lute Player* (detail), 1596–1597. Private collection
▶ **Il Perugino** (Pietro Vannucci, known as) *St. Sebastian*, 1500. Paris, Louvre

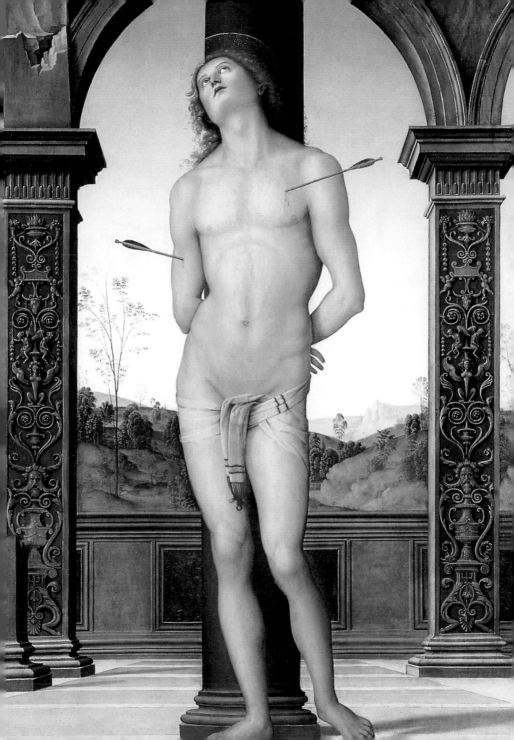

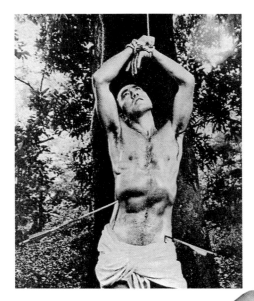

▲ The writer Yukio Mishima posing as Saint Sebastian for his friend the photographer Kishin Shinoyama

▶ Mishima posing as a Samurai for the cover of his book *Sun and Steel*

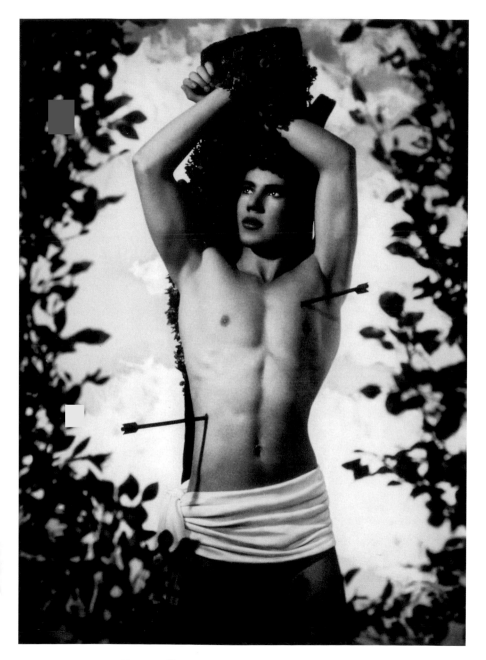

Pierre & Gilles *St. Sébastien – Bouabdallah Benkamla*, 1987.
Collection Walter Haas, Zurich

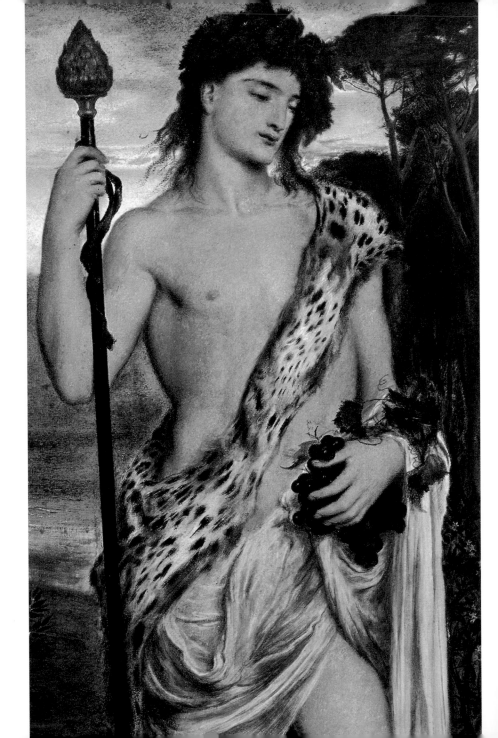

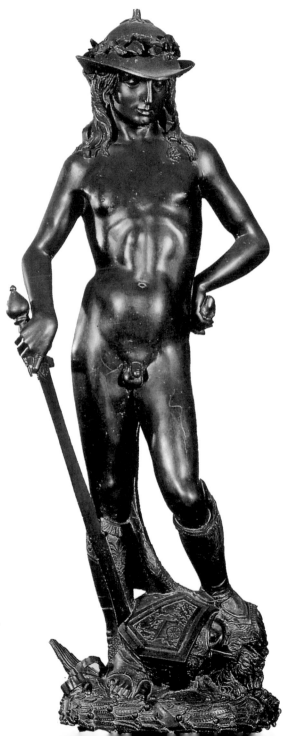

◄ Simeon Solomon
Bacchus illustration
for the 1914 edition of
Oscar Wilde's poem
The Sphinx

◄ Donatello *David*,
1440–1443. Florence,
National Museum
of the Bargello

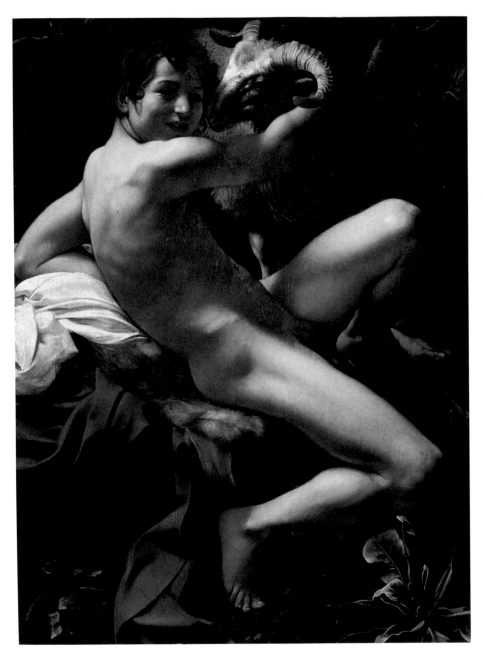

▲ **Caravaggio** *St. John the Baptist*, 1599–1600. Rome, Capitol Museum
► **Roberto Márquez** *Angel Vampiro*, 1995

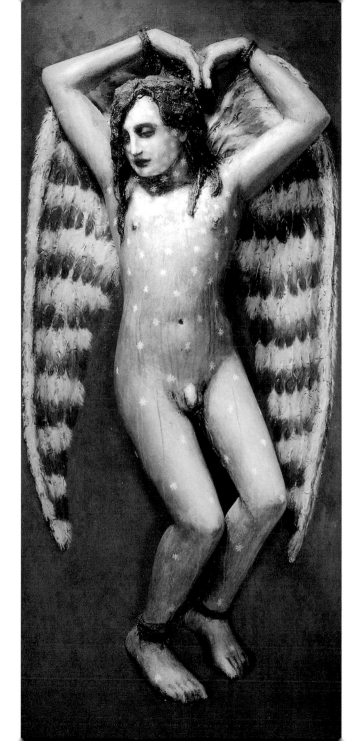

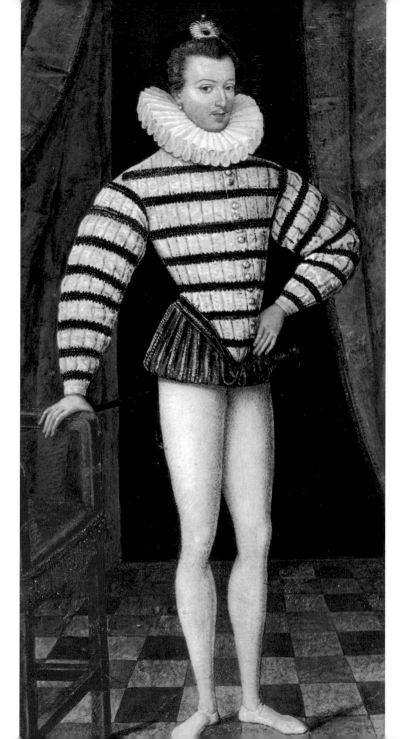

◄ **Anonymous** *Portrait
of Henry III's minion,
Marquis de Saint-Mégrin.*
Miniature, 16th century.
Paris, Louvre.
It was said that, when he
died, Saint-Mégrin gave
"his soul to God, his
body to the ground and
his arse to the Devil."

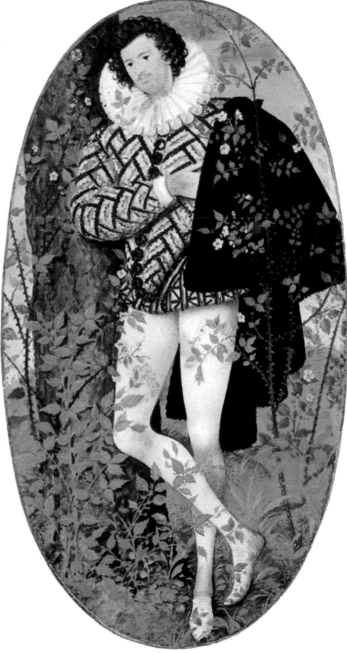

► **Nicolas Hilliard**
*Portrait of an
Unknown Man*,
16th century. London,
Victoria and Albert
Museum

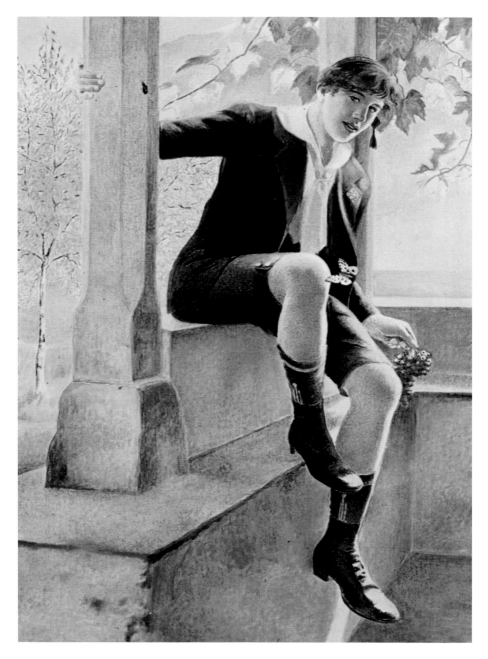

Elisar von Kupffer One of the young models who frequented the sanctuary built in 1927
by the artist, who lived there with his friend the philosopher Eduard von Mayer

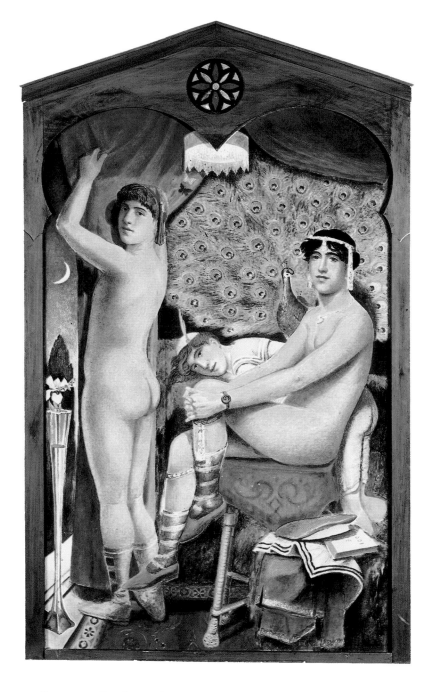

▲ **Elisar von Kupffer** *Klarismus (Supreme Clarity)*. Minusio, Sanctuarium Artis Elisarion 101

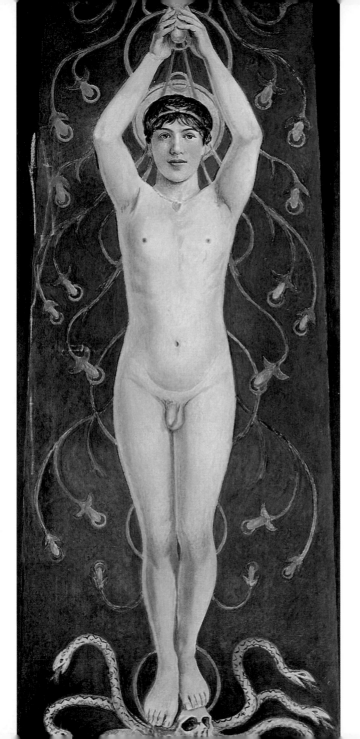

◄ **Elisar von Kupffer**
Odalisque. Minusio,
Sanctuarium Artis
Elisarion

► **Boris Orlowski**
Faun, c. 1820.
St. Petersburg, The
State Russian Museum

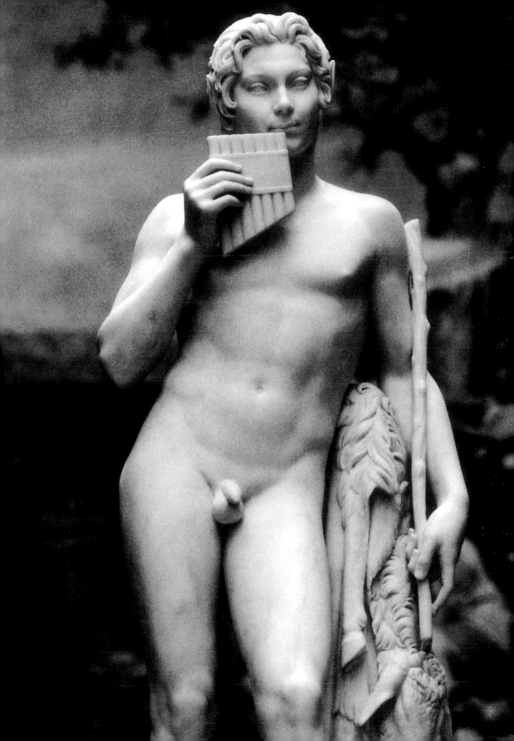

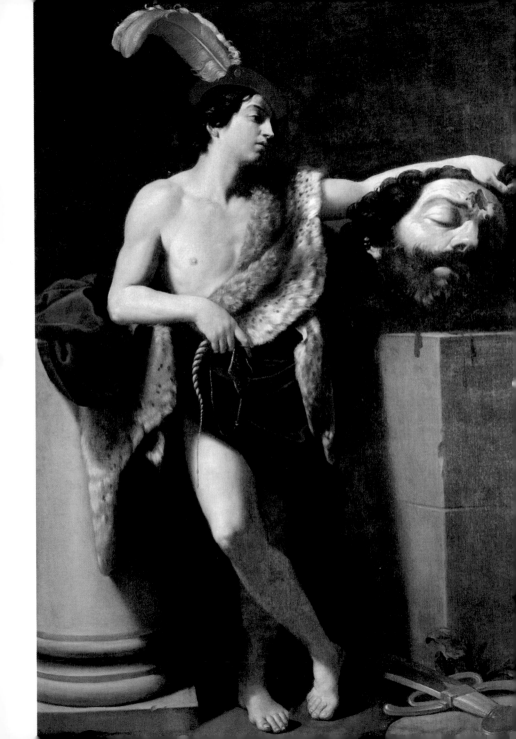

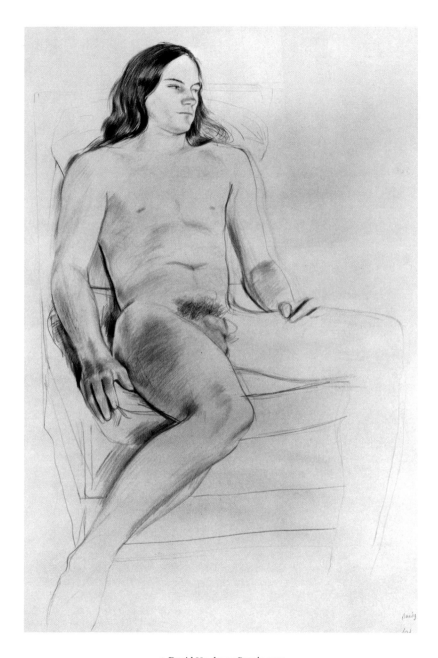

▲ David Hockney *Randy*, 1974
◄ Giovan Francesco Cresci (after Guido Reni) *David with the Head of Goliath*, 1619–1620.
Sarasota, The John and Mable Ringling Museum of Art

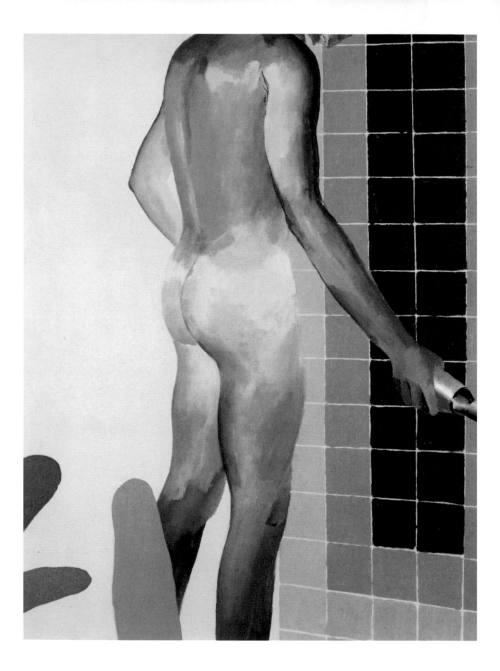

▲ David Hockney *Boy about to Take a Shower*, 1964
► Pierre Puvis de Chavannes *The Little Fisherman*, c. 1880

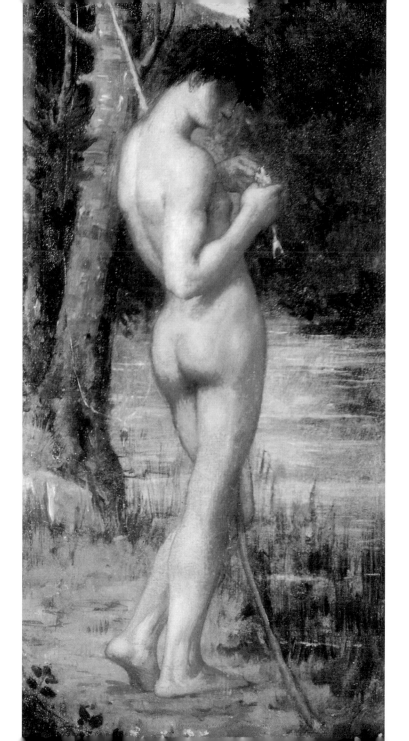

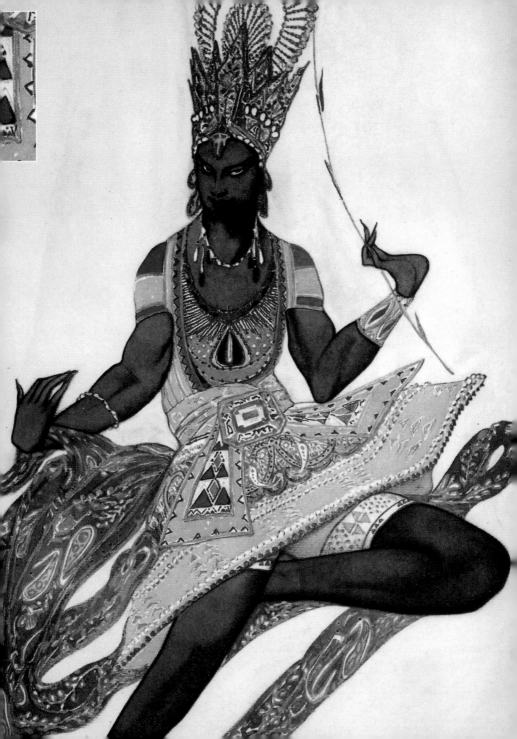

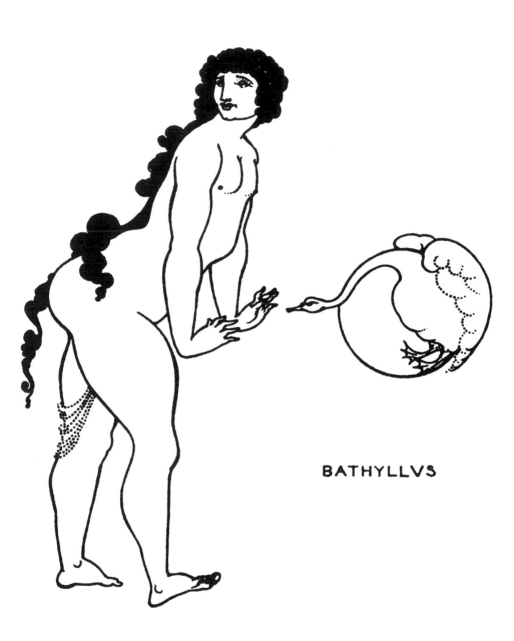

BATHYLLVS

▲ **Aubrey Beardsley** *Bathyllus's Swan Dance*, 1906. Illustration for Juvenal's *Satire VI*
◄ **Leon Bakst** *Nijinski in the Title Role of the Blue God*, 1912.
Paris, National Opera Library and Museum

BATHYLLVS

▲ **Aubrey Beardsley** *Bathyllus*, 1906. Illustration for Juvenal's *Satire VI*
► **Leon Bakst** Portrait of Vaslav Nijinsky in Claude Debussy's *L'après-midi d'un faune*
►► **Jean-Léon Gérôme** *The Snake Charmer*, c. 1870. Sterling and Francine Clark Art Institute,
Williamstown, MA. A typical paedophile work by a Pompier artist,
including phallic serpent, young boy, and voyeur

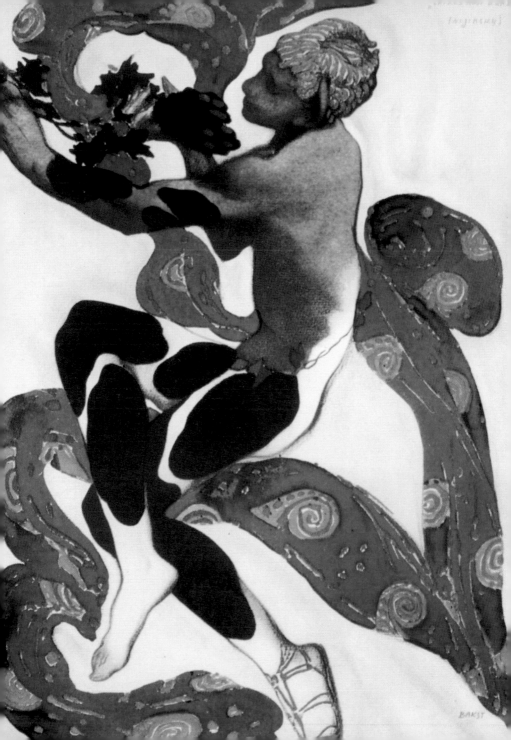

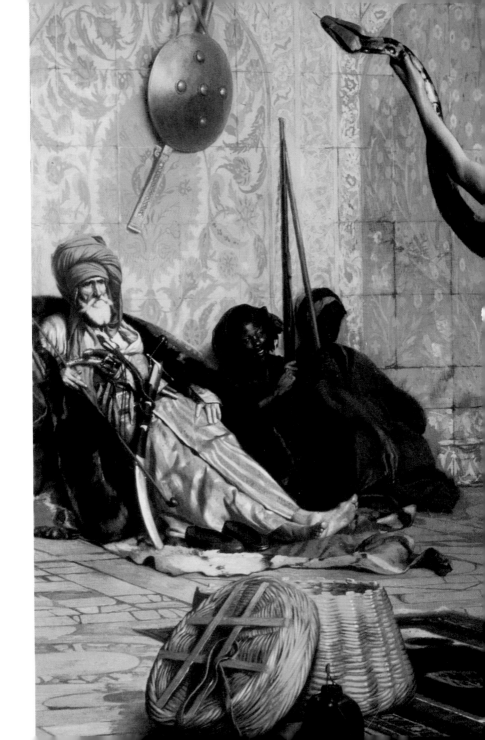

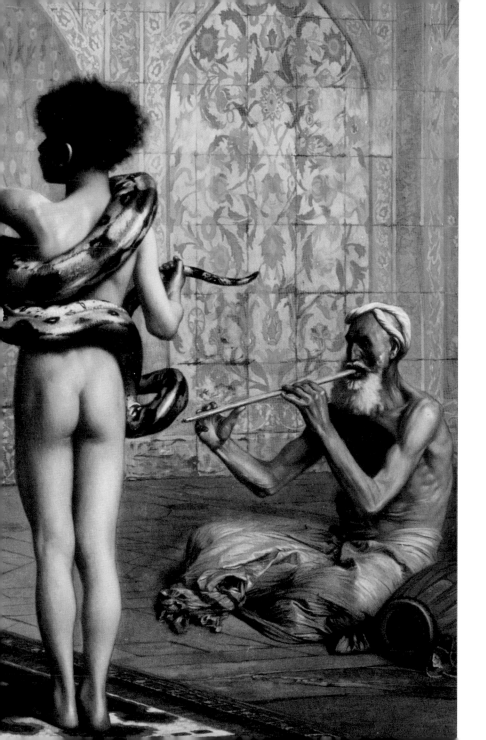

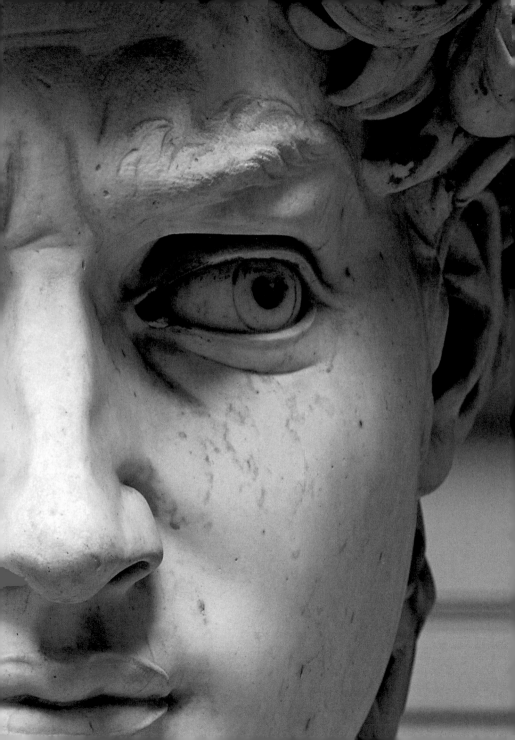

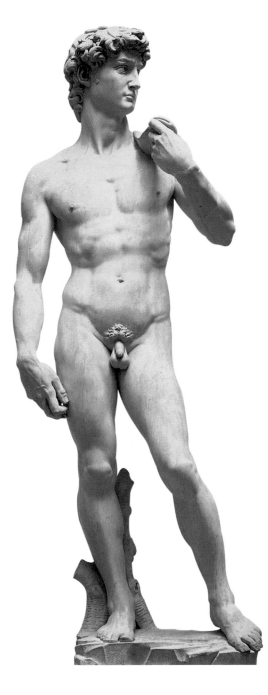

◄ (detail)/▲ **Michelangelo** *David*, 1501–1504. Florence, Gallery of the Academy　　115

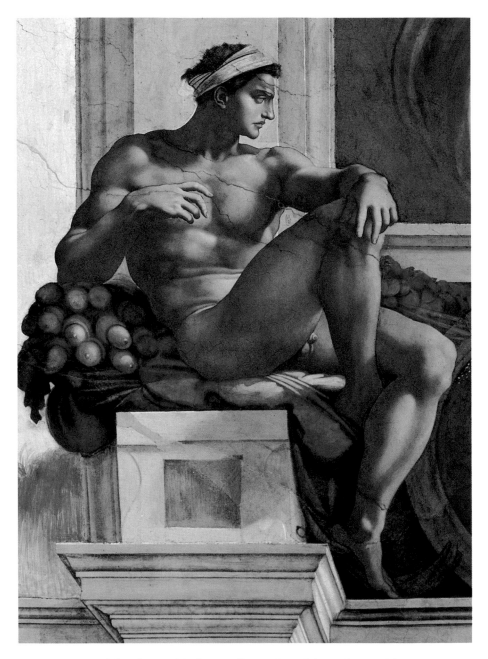

Michelangelo One of the four *Ignudi* grouped round the prophet Jeremiah.
Detail from *The Creation of the World*, 1510–1511. Rome, Sistine Chapel

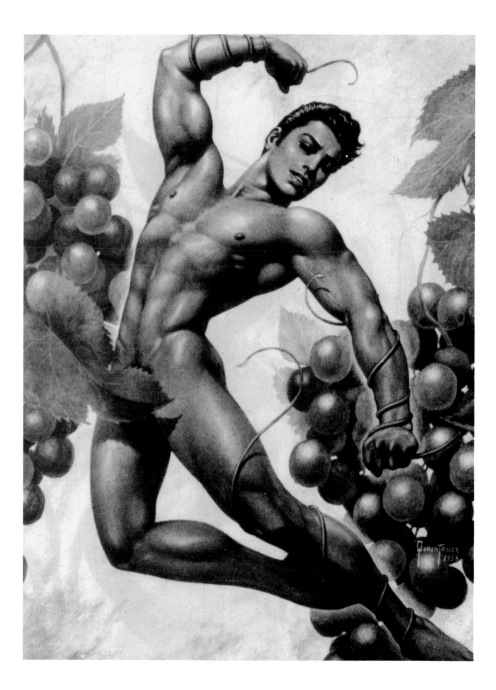

George Quaintance *Bacchant*, 1956. The acorns have been replaced by grapes…

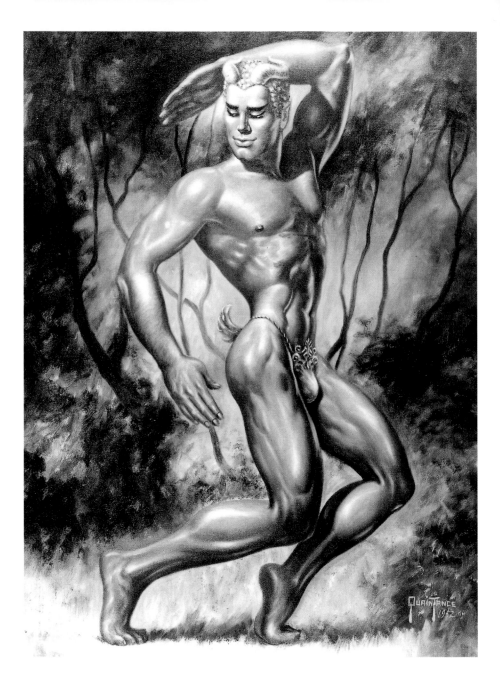

118 **George Quaintance** *Golden Faun*, 1952

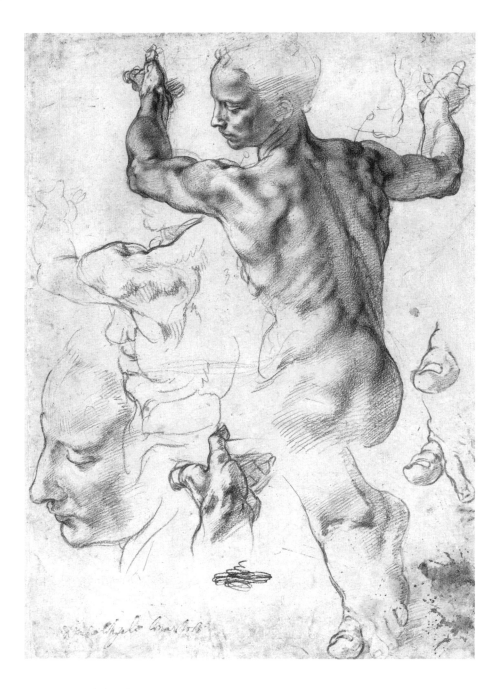

▲ **Michelangelo** *Study for the Libyan Sibyl*, 1511. New York, Metropolitan Museum of Art

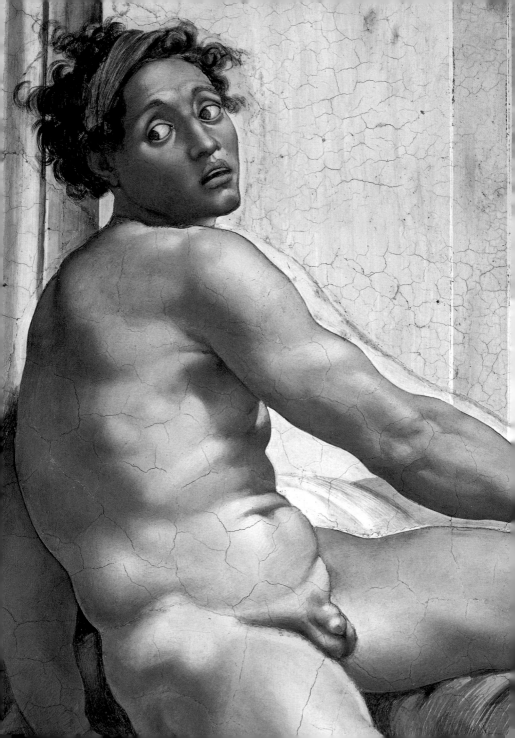

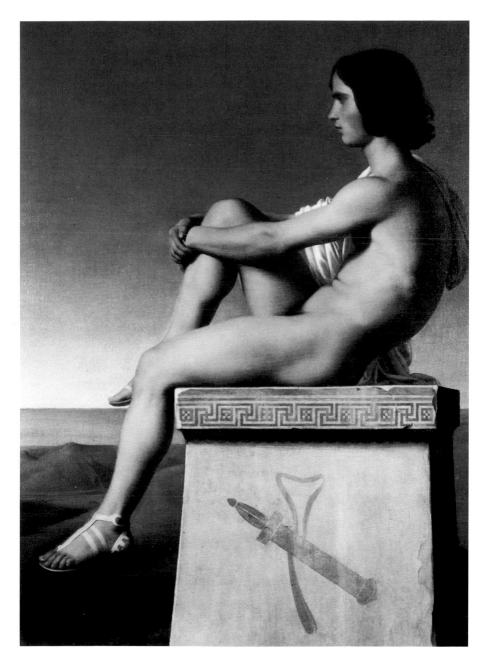

▲ Hippolyte Flandrin *Polites, son of Priam*, 1834. Saint-Étienne, Museum of Art and History
◀ Michelangelo *Ignudi* (detail), 1509. Rome, Sistine Chapel. Detail taken from close to *The Flood* 121

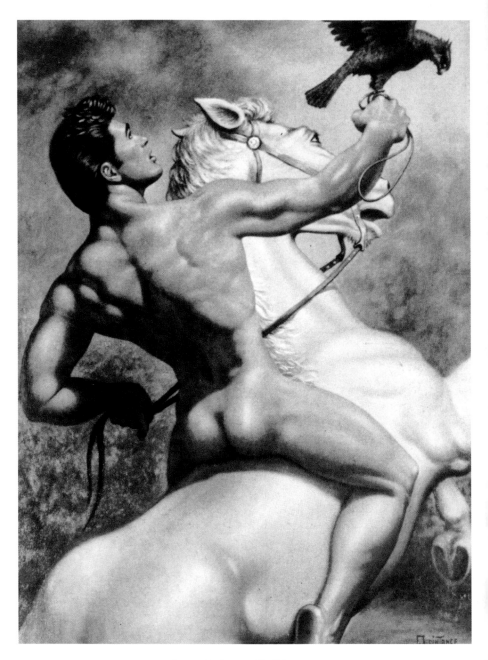

▲ George Quaintance *The Falconer*, 1957
► Jacques-Louis David *The Sabine Women* (detail), 1796–1799. Paris, Louvre

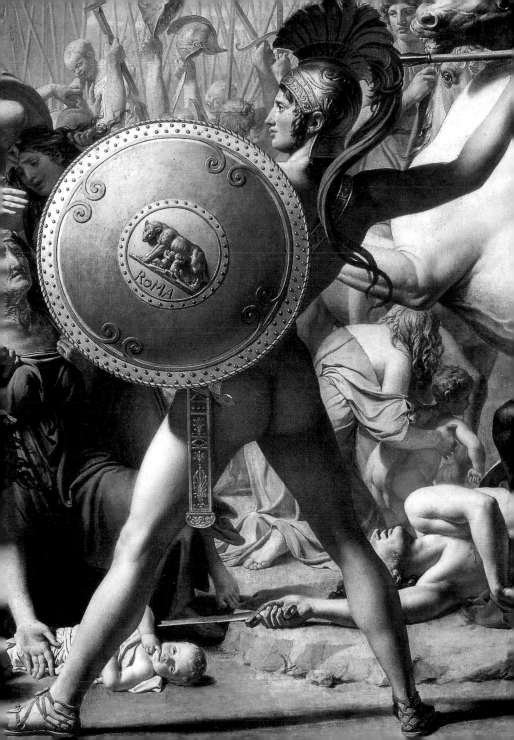

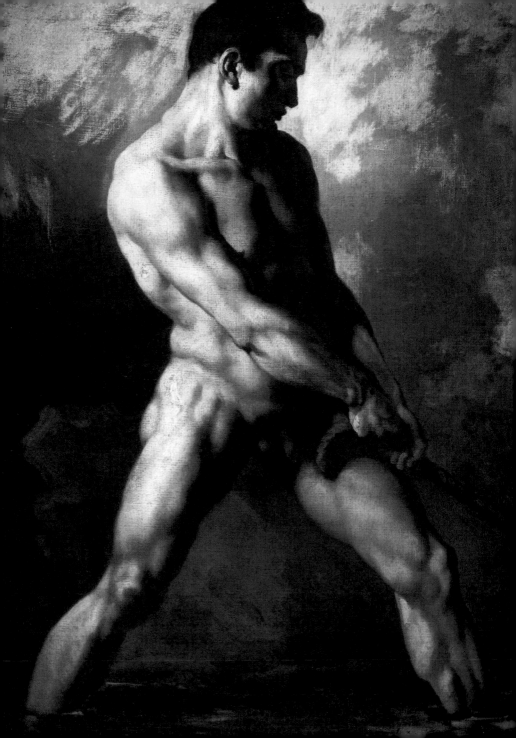

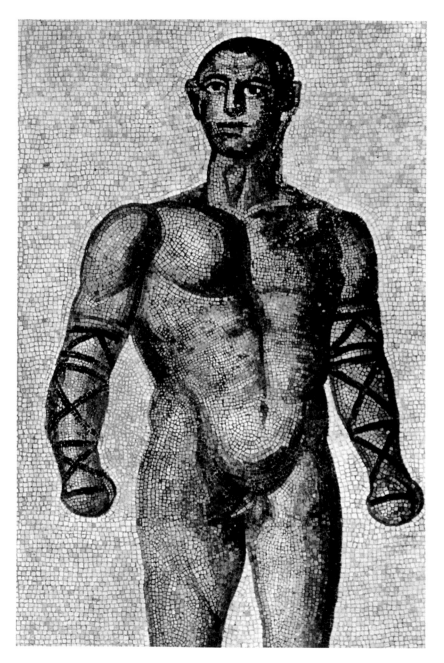

▲ Mosaic from the Baths of Caracalla: *Roman wrestler*
◄ Jean Géricault *Studies of Male Nudes* (detail), 1855. Bayonne, Bonnat Museum

PHYSIQUE
PICTORIAL

35 CENTS

George Quaintance Two covers of *Physique Pictorial*, 1952–1953

PHYSIQUE PICTORIAL

35 CENTS

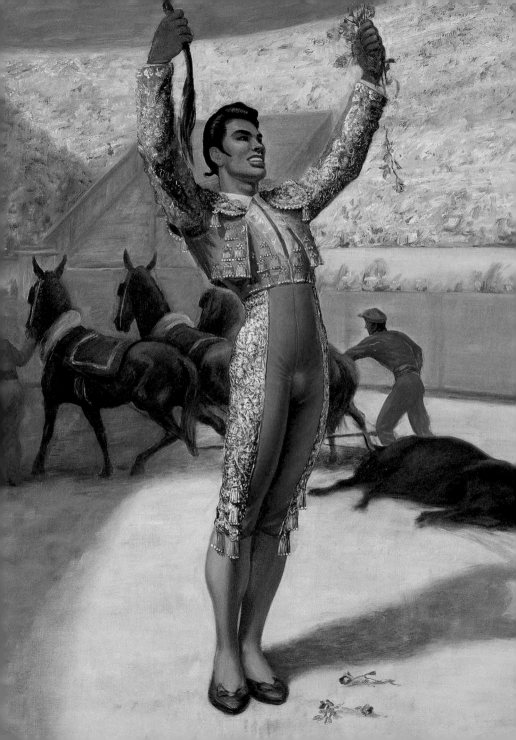

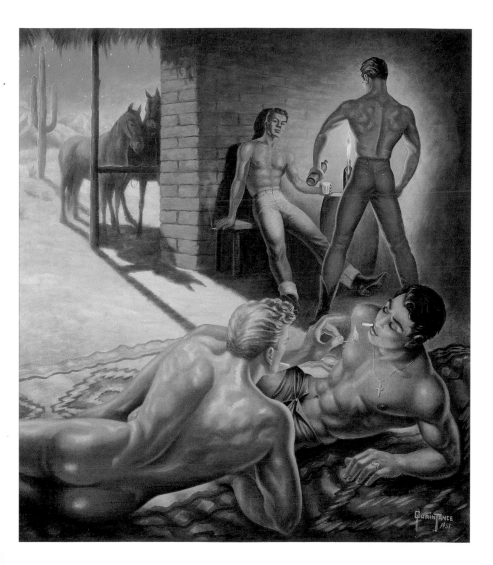

▲ George Quaintance *Night in the Desert*, 1951. Cologne, private collection
◄ George Quaintance *Gloria*, 1953. Cologne, private collection

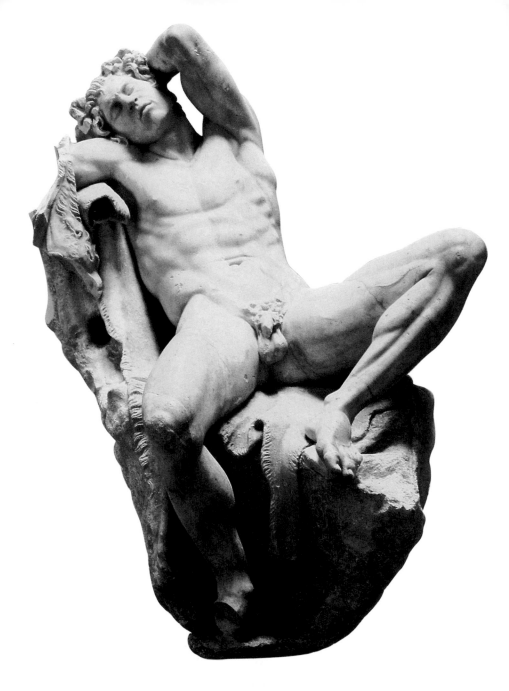

Sleeping Satyr, 220 BC. Munich, State Collection of Antiques and Sculpture

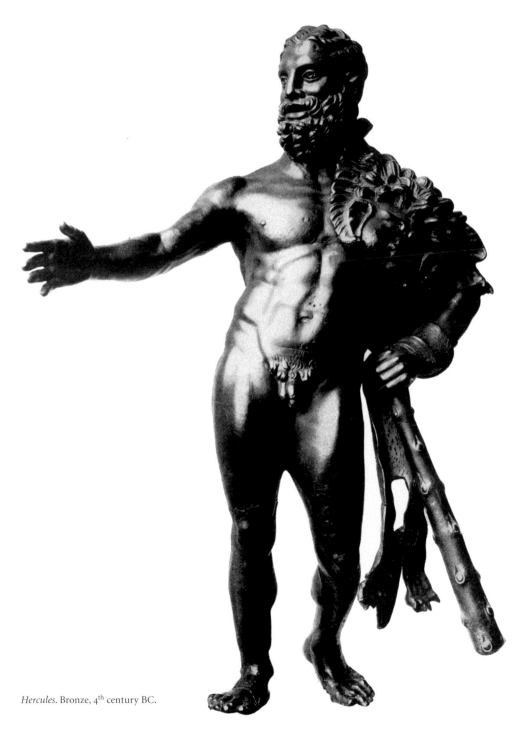

Hercules. Bronze, 4th century BC.

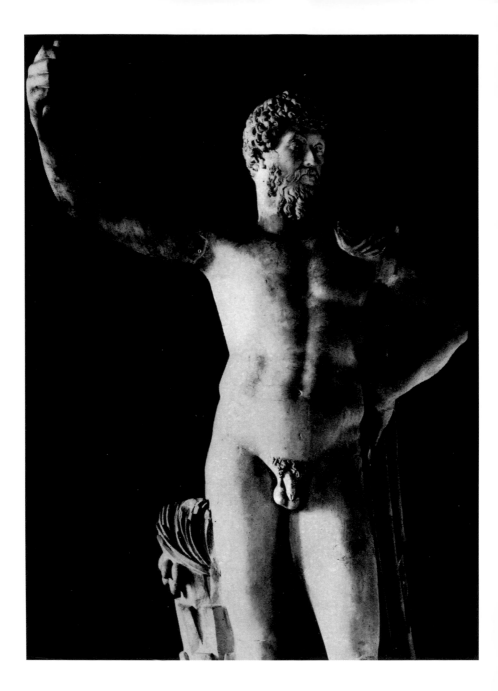

Marcus Aurelius. Paris, Louvre

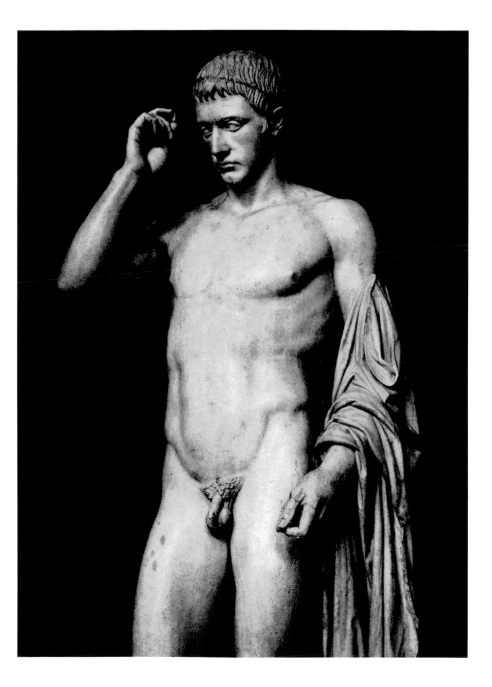

Julius Caesar. Paris, Louvre

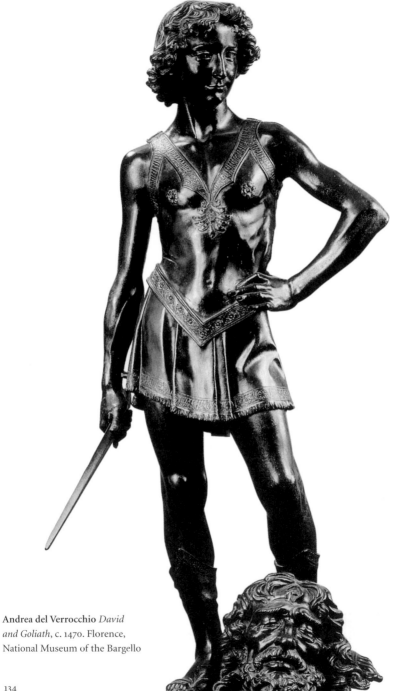

Andrea del Verrocchio *David and Goliath*, c. 1470. Florence, National Museum of the Bargello

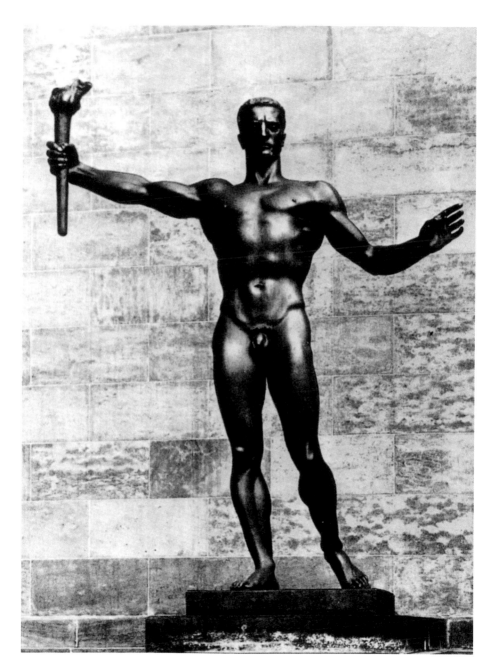

Arno Breker *The Party,* which used to stand in front of the New Chancellery
in Berlin (now destroyed), 1939

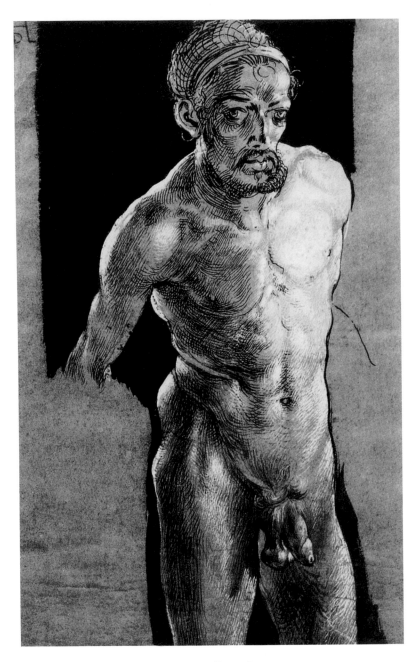

▲ Albrecht Dürer *Self-portrait*, 1503–1506
▶ Arno Breker *Prometheus*. Bronze, 1937. Bitburg, Dr. Hanns Simon Foundation

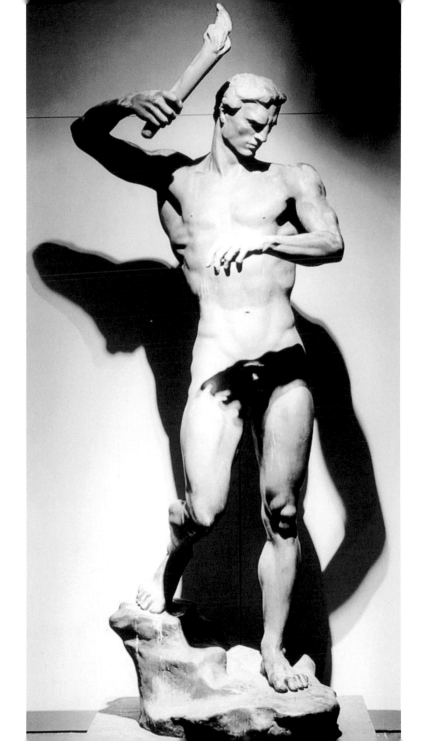

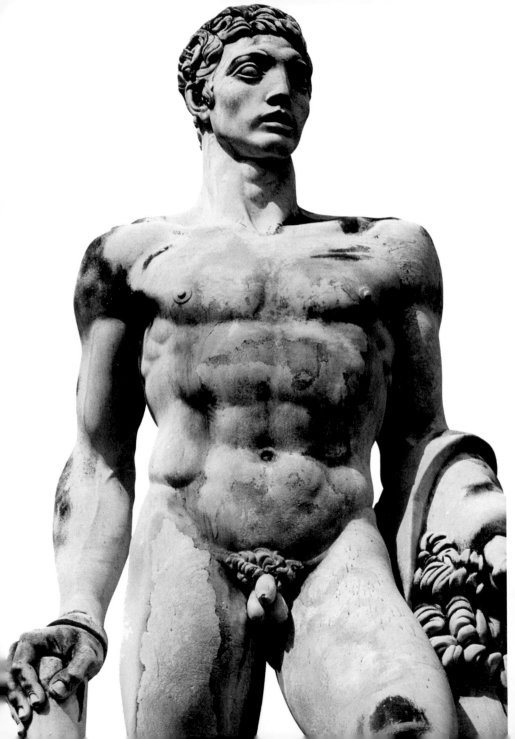

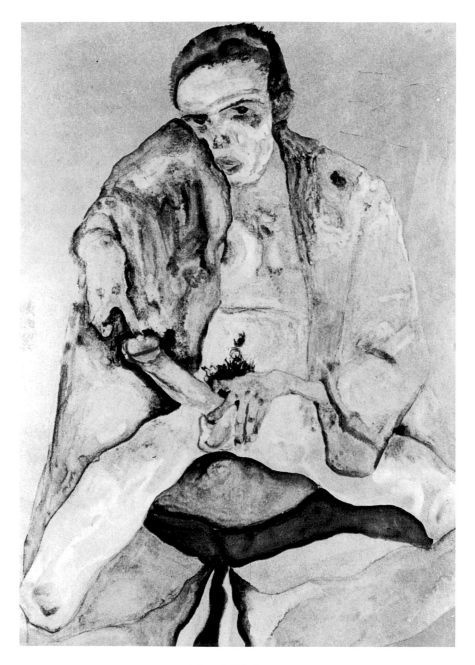

▲ Egon Schiele *Eros*, 1911
◄ Silvio Canevari *Catania*. Marble, 1932. Rome, Marmi Stadium. Pure Mussolinian style... 139

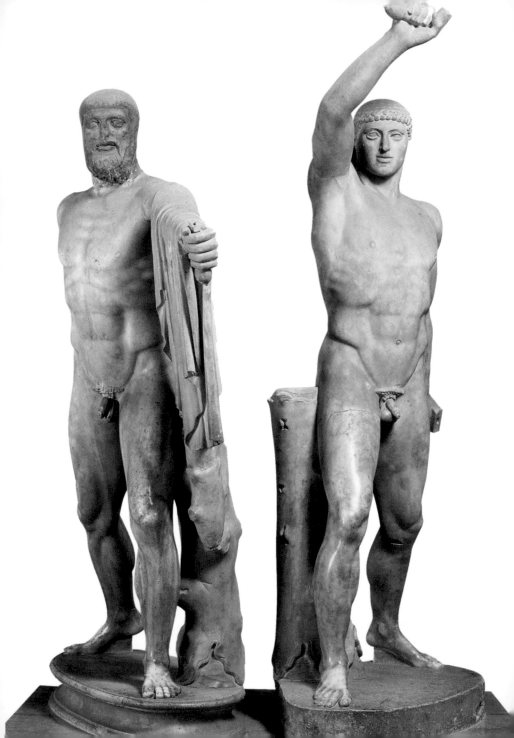

Love that dares to say its name

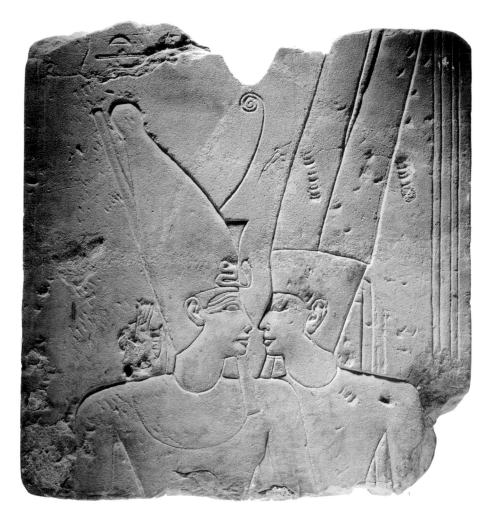

▲ *The god of love embracing the pharaoh Ramses II.* Bas-relief from the temple
of Karnak, 1290–1224 BC. Paris, Louvre
◄ **Kritios and Nesiotes** *The Tyrannicides,* 477/6 BC. Naples, National Archaeological Museum
The two lovers who restored Athenian democracy by assassinating the tyrant Hipparchos
►► *Corydon and Alexis,* or *Orestes and Pylades,* or *Castor and Pollux…*
Marble. Madrid, Prado Museum

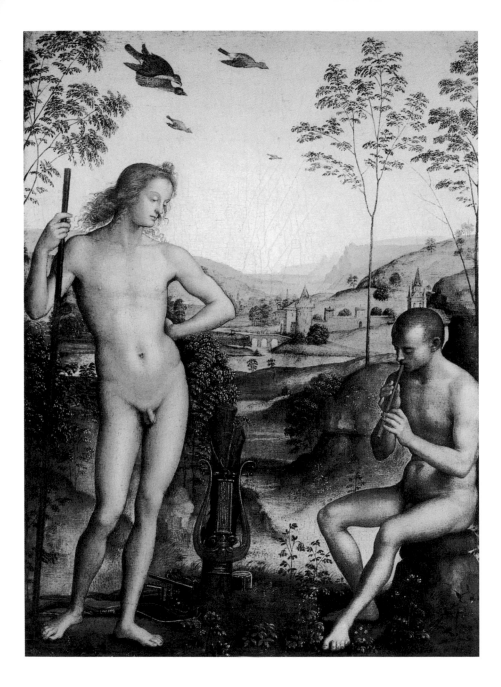

▲ **Il Perugino** *Apollo and Marsyas*, 1475–1505. Paris, Louvre

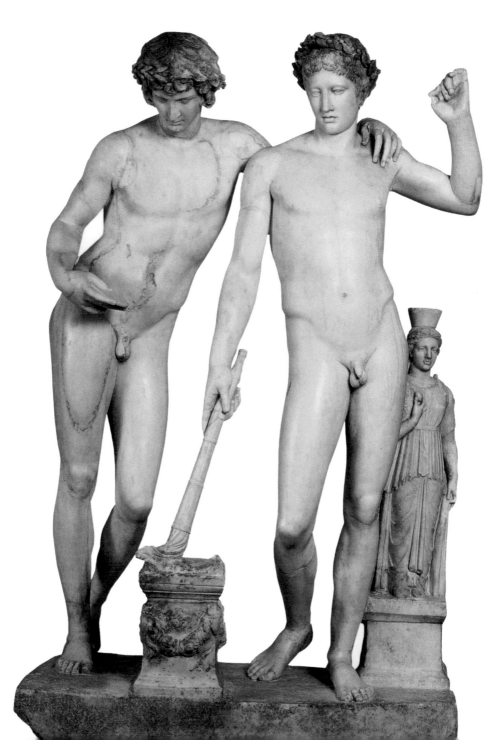

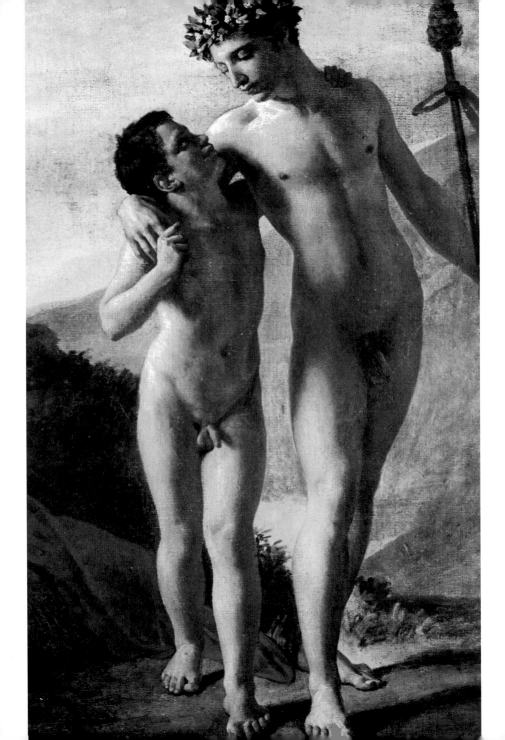

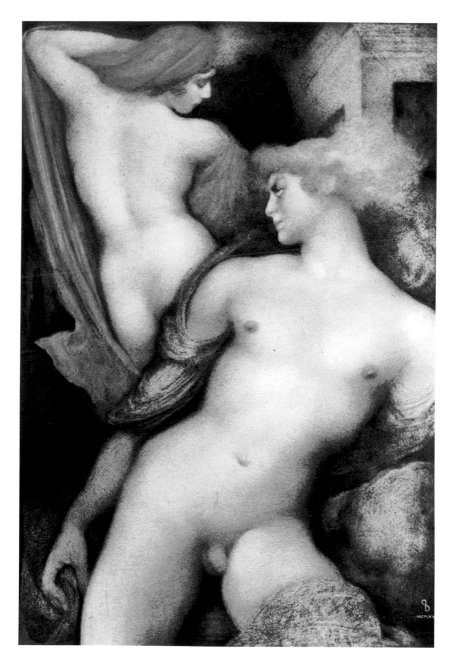

▲ **Leonard Sarluis** (friend of Oscar Wilde) *Classical Couple.* Collection of Félix Marcilhac
◄ **Anonymous** *Virgilian Shepherds*, c. 1820

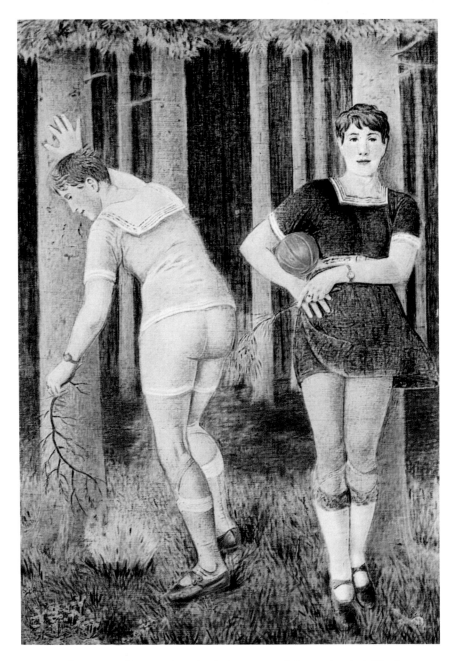

▲ **Elisar von Kupffer** *Recreation.* Minusio (near Locarno), Sanctuarium Artis Elisarion
► **Jean Broc** *Death of Hyakinthos*, c. 1801. Poitiers, Museum of Fine Arts

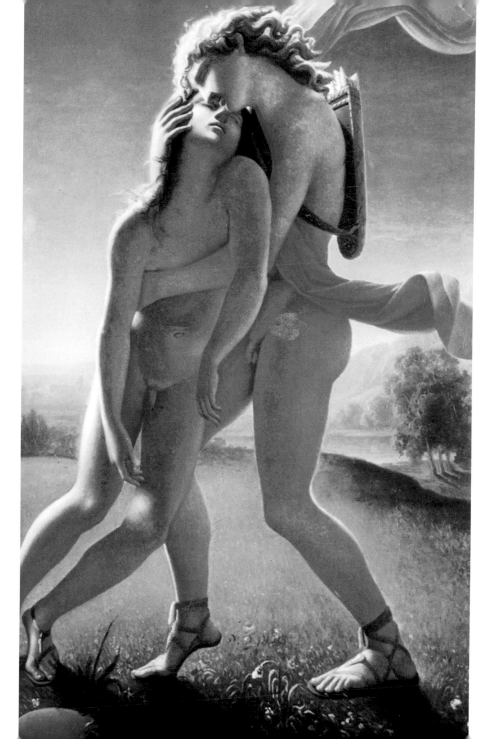

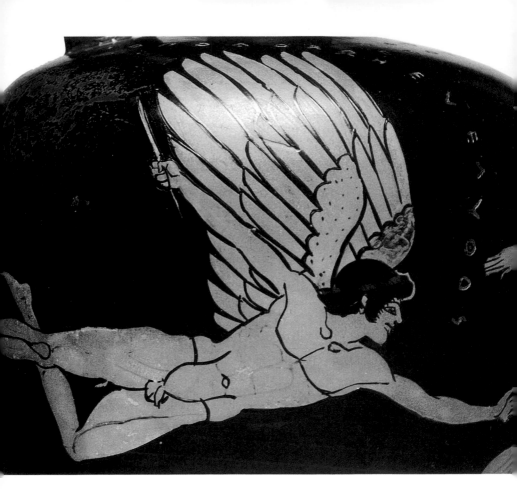

▲ Attic shouldered red-figure Lekythos by the vase painter
Douris, who painted this one as a present for his lover Aso-
podore in memory of their first love chase "Terrible Eros",
c. 470–460 BC. Athens, National Archaeological Museum

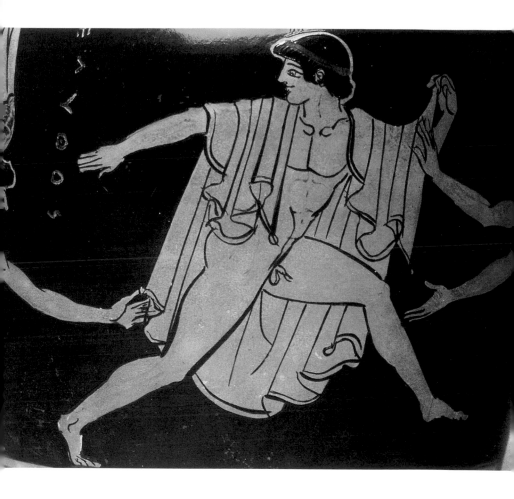

► Greek bowl (detail), 6th century BC. Paris, Louvre. Silenus and satyrs revelling in what Martial called a "chain of voluptuousness"

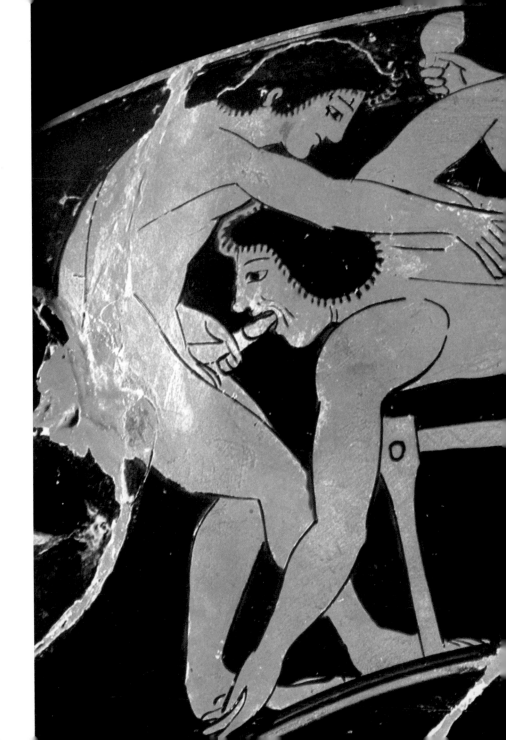

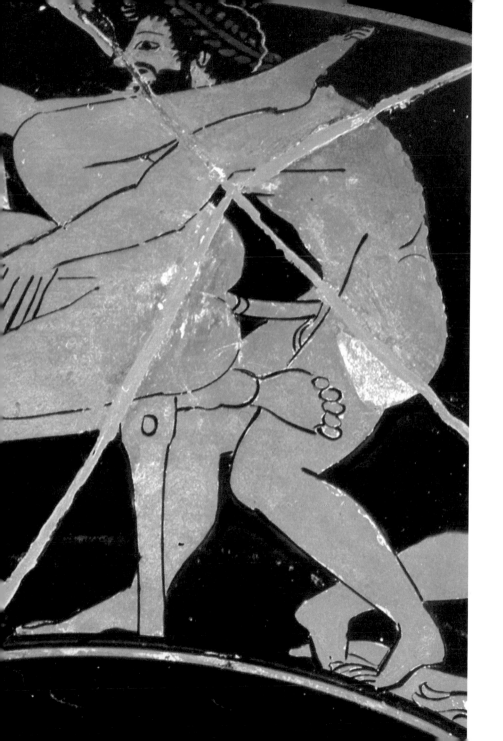

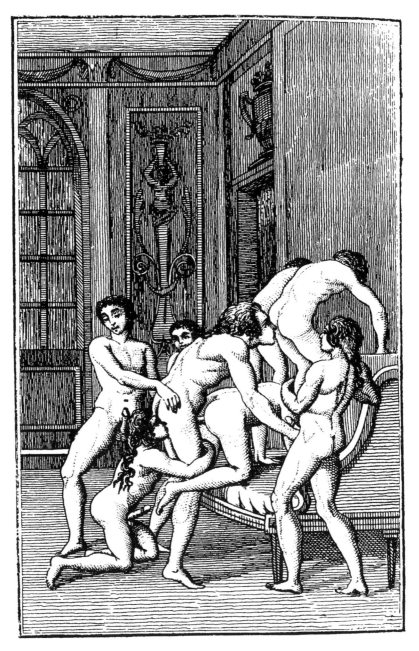

Engravings from the 1797 Dutch edition of de Sade's
La Nouvelle Justine; ou, Les Malheures de la vertue

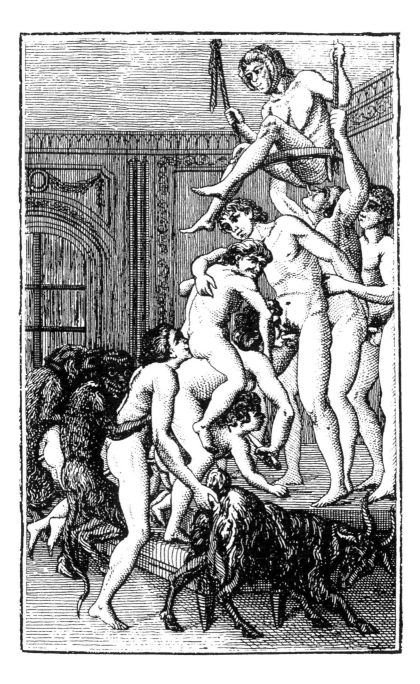

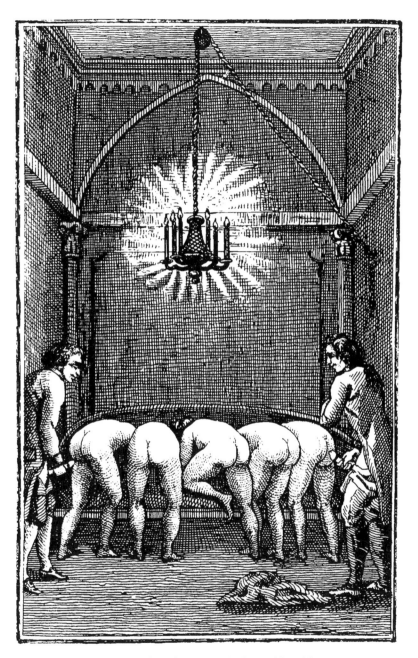

Engravings from the 1797 Dutch edition of de Sade's
La Nouvelle Justine; ou, Les Malheures de la vertue

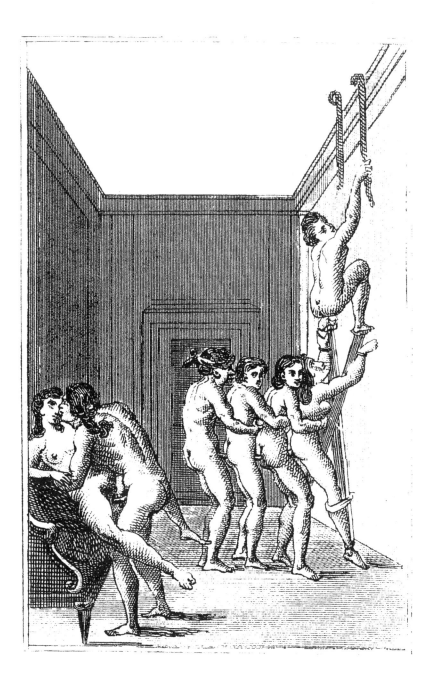

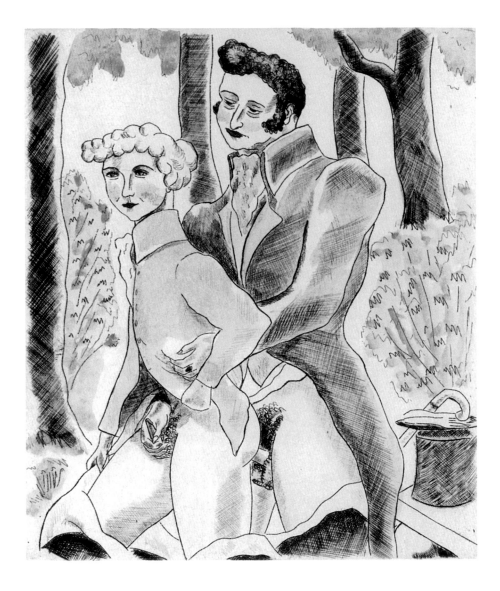

Anonymous *The Hermaphrodite.*
Illustration for Pierre-Jean de Béranger's *Chansons Erotiques*, c. 1820

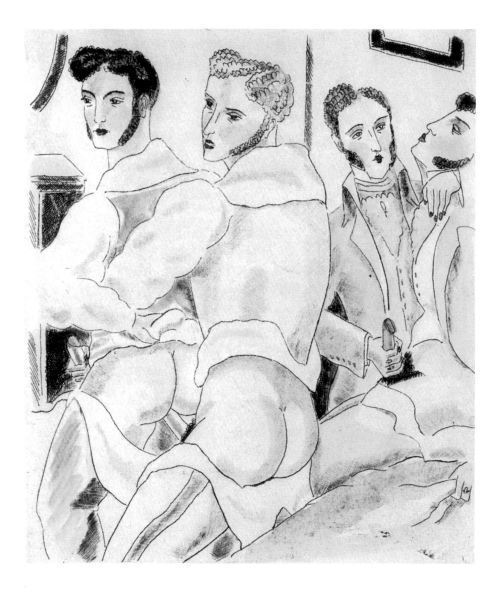

Anonymous *Carme's Sermon.*
Illustration for Pierre-Jean de Béranger's *Chansons Erotiques*, c. 1820

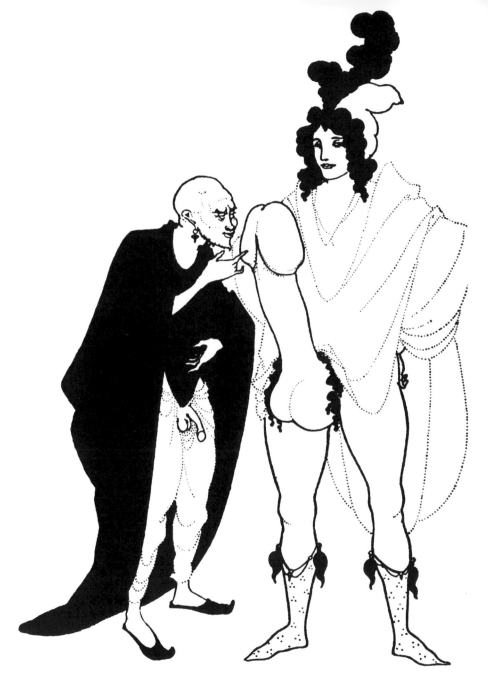

Aubrey Beardsley *The Examination of the Herald.*
Illustration for Aristophanes' *Lysistrata*, 1896

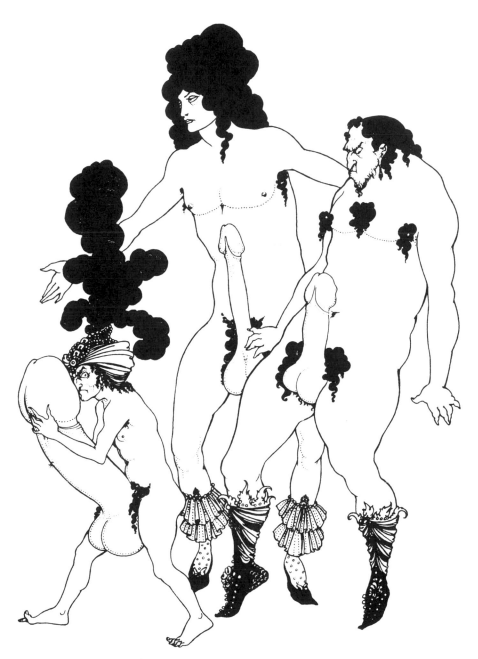

Aubrey Beardsley *The Lacedaemonian Ambassadors.*
Illustration for Aristophanes' *Lysistrata*, 1896

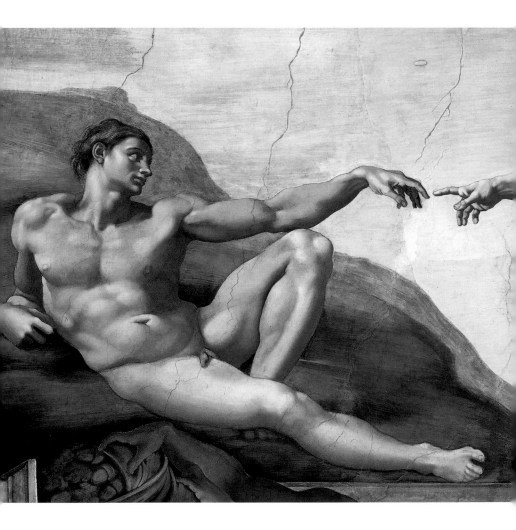

Michelangelo *The Creation of Adam* (detail), 1510–1511.
Rome, Sistine Chapel

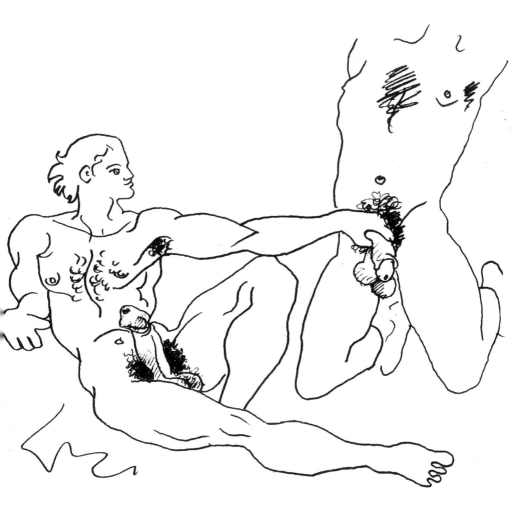

Jean Cocteau A reinterpretation of Michelangelo's
The Creation of Adam…(from *Mythologie,* 1940s) 161

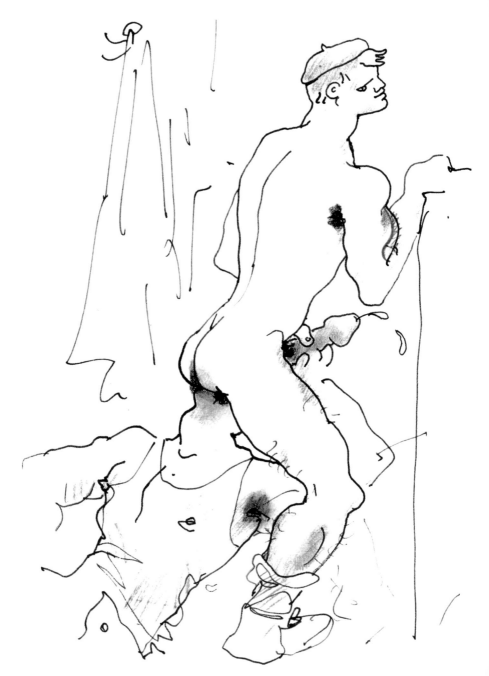

Jean Cocteau *Dargelos the Schoolboy.* Illustration from *Le Livre Blanc*, 1927

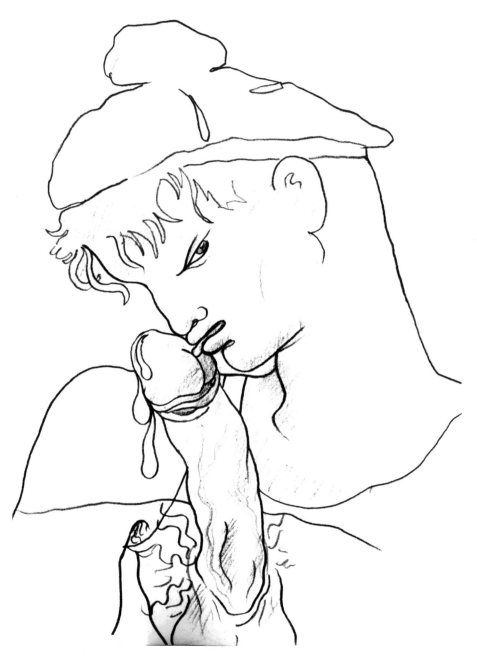

Jean Cocteau Illustration for the novel *Querelle de Brest* by Jean Genet, 1947

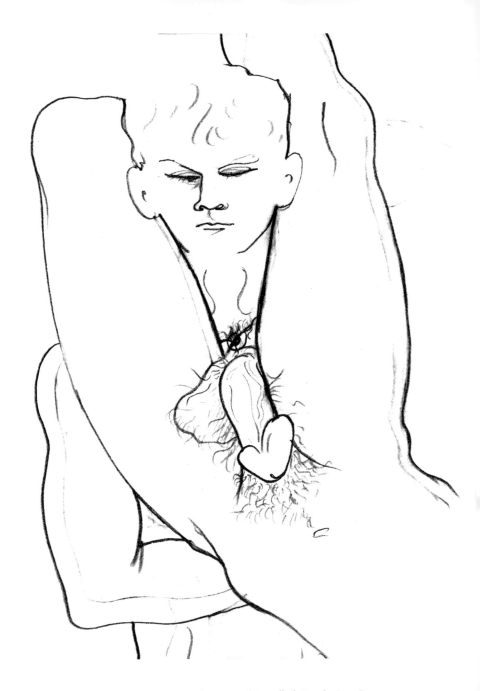

Jean Cocteau Two illustrations for the novel *Querelle de Brest* by Jean Genet, 1947

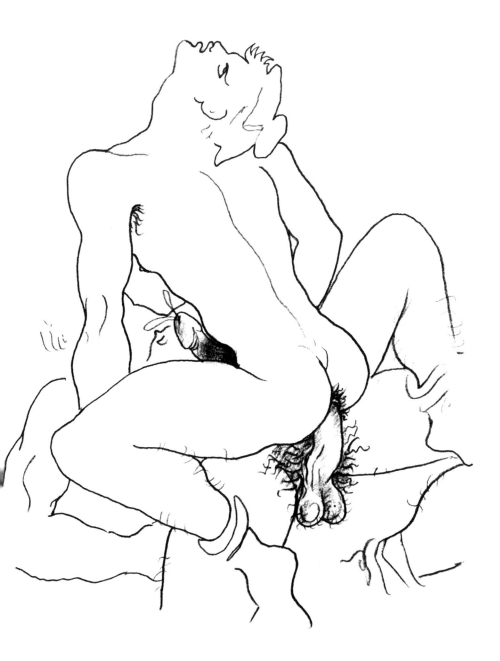

Jean Cocteau Two illustration for the novel *Querelle de Brest* by Jean Genet, 1947

Bernard Montorgeuil Two illustrations from the work *Dressage*, 1930s

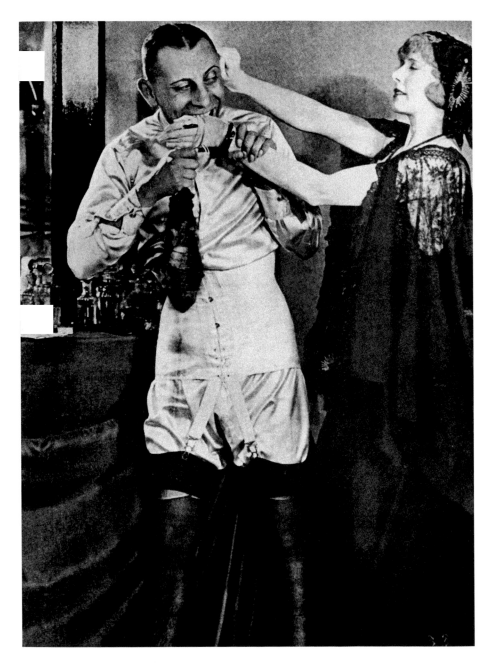

Erich von Stroheim, as a fetishistic transvestite, and Mae Busch,
in his film *Foolish Wives* (scene censored)

Pierre & Gilles *Lola*, 1992. Cologne, private collection
Lola, of course, can only be a transvestite...

171

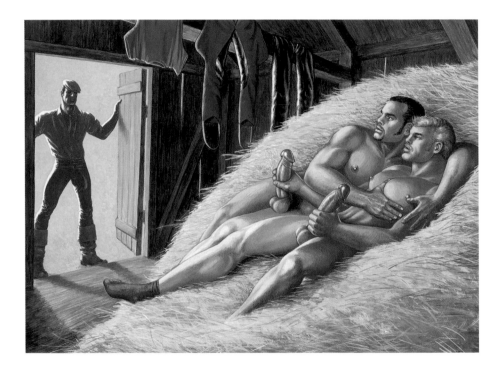

Tom of Finland *Untitled (Barn Scene)*, 1975. Cologne, private collection

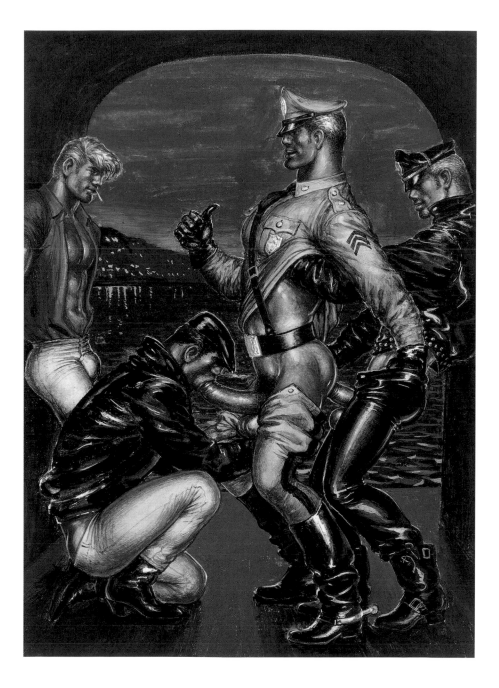

Tom of Finland *Untitled*, 1975. Cologne, private collection

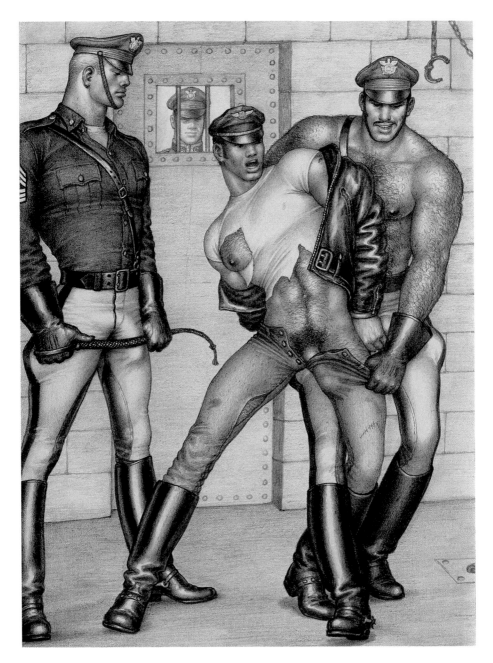

Tom of Finland *Untitled (Being Stripped)*, 1975.
Cologne, private collection

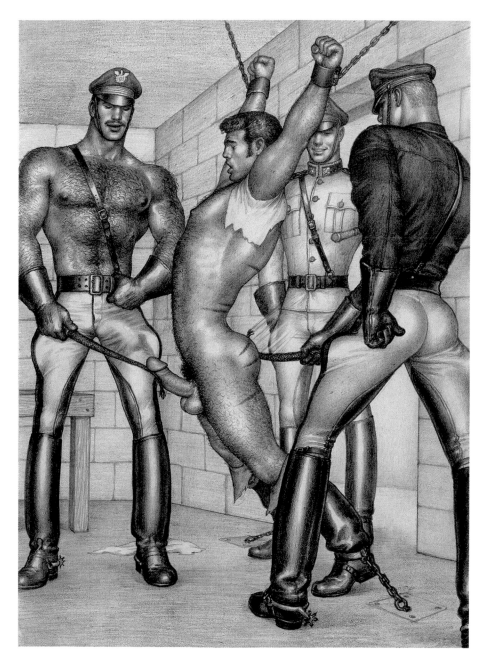

Tom of Finland *Untitled (Chained / Standing)*, 1975.
Cologne, private collection

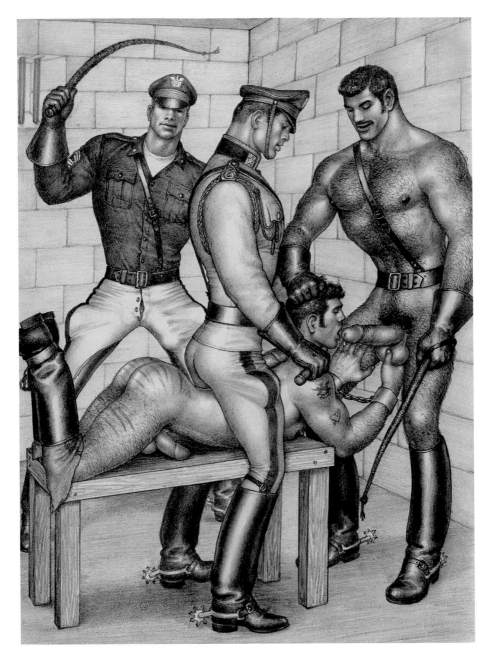

Tom of Finland *Untitled (Mounted / On Bench)*, 1975.
Cologne, private collection

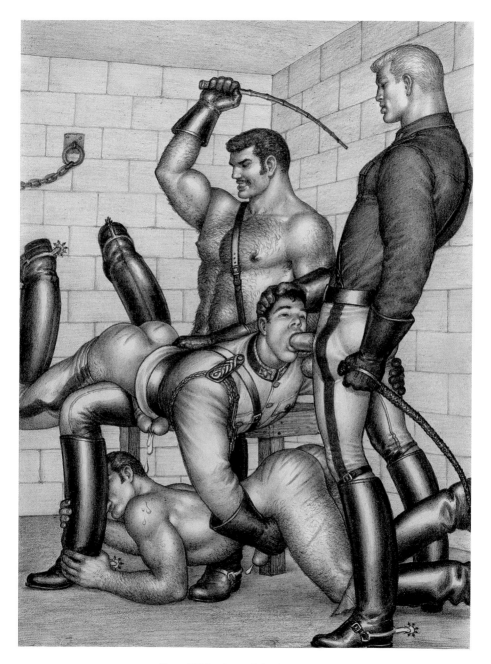

Tom of Finland *Untitled (Blowjob)*, 1975.
Cologne, private collection

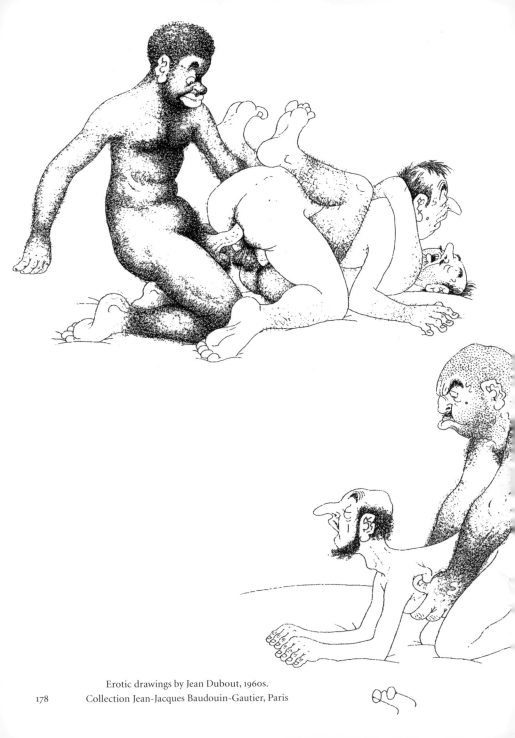

Erotic drawings by Jean Dubout, 1960s.

Collection Jean-Jacques Baudouin-Gautier, Paris

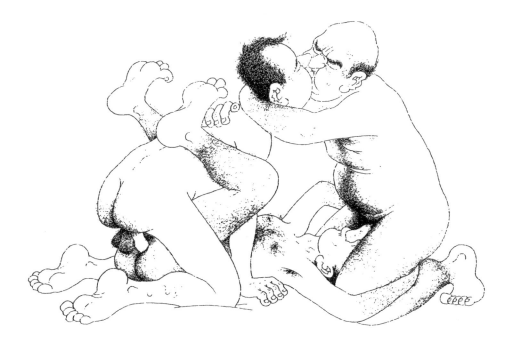

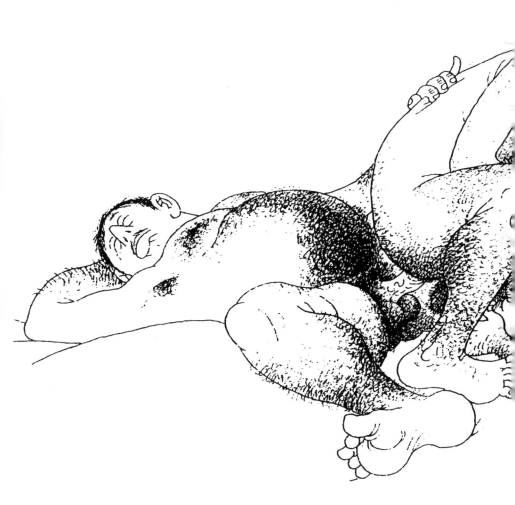

Erotic drawing by Jean Dubout, 1960s.
Collection Jean-Jacques Baudouin-Gautier, Paris

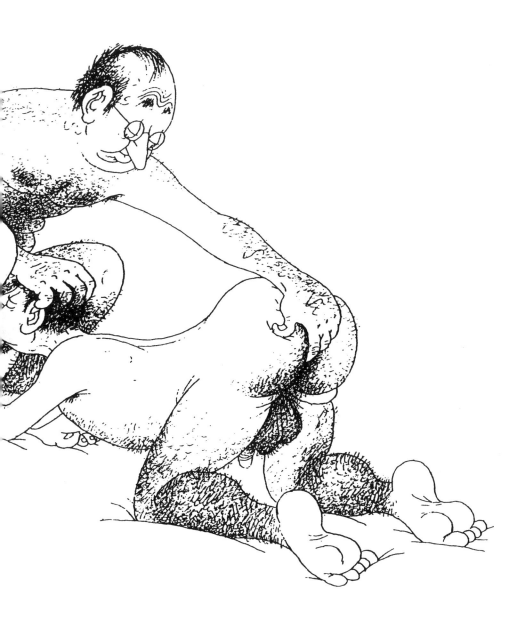

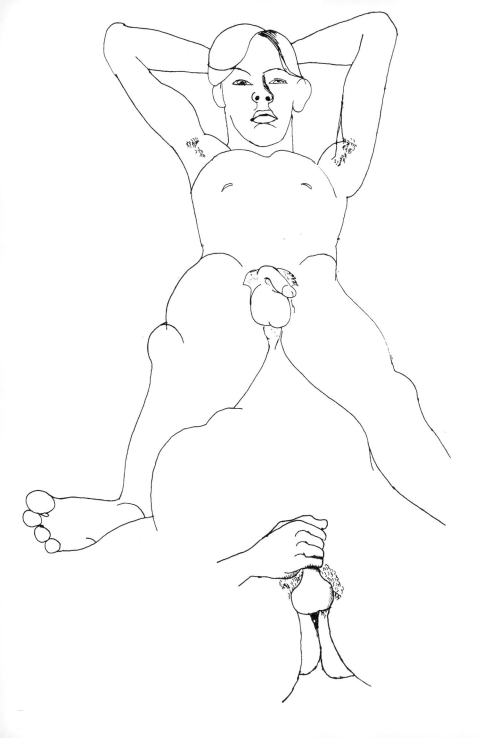

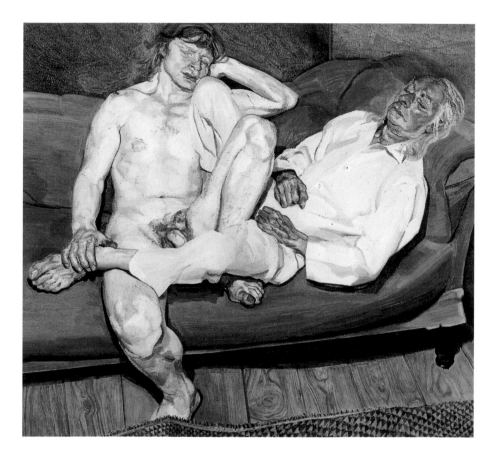

▲ Lucian Freud *Naked Man with Friend*, 1978–1980
◄ Lucian Freud *Boy on a Bed*, 1943

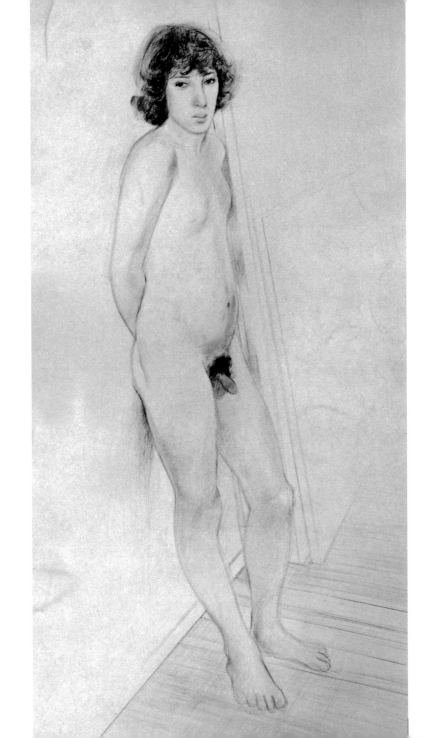

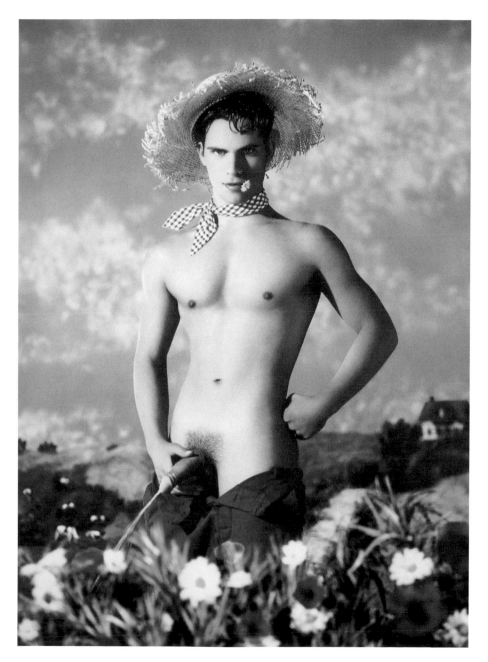

▲ **Pierre & Gilles** *Le Petit Jardinier – Didier*, 1994. Collection Harry Lunn Jr., New York
◄ **David Hockney** *Gregory Standing Nude*, 1975. Paris, Claude Bernard Gallery

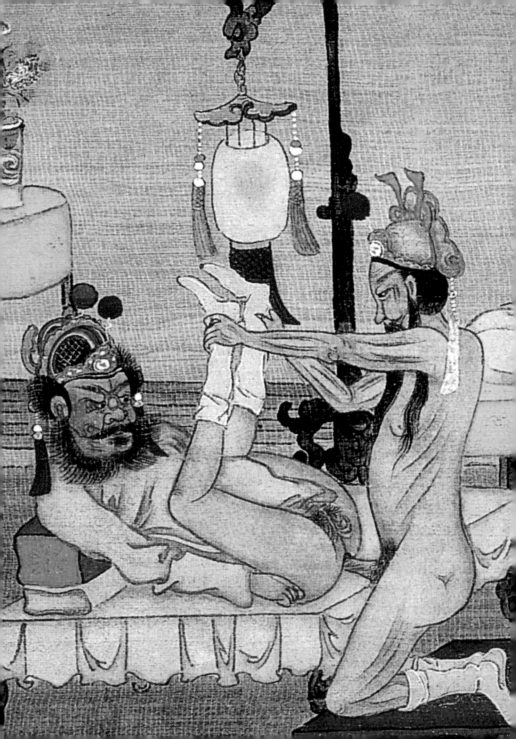

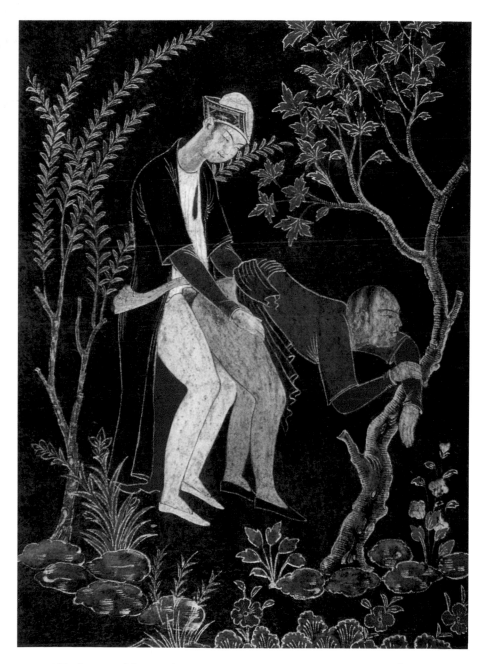

▲ *Two homosexuals in a camphor grove*. Persian miniature in the Sefevid style, late 18th century
◄ *Two cross-dressing actors*. Qing dynasty, China

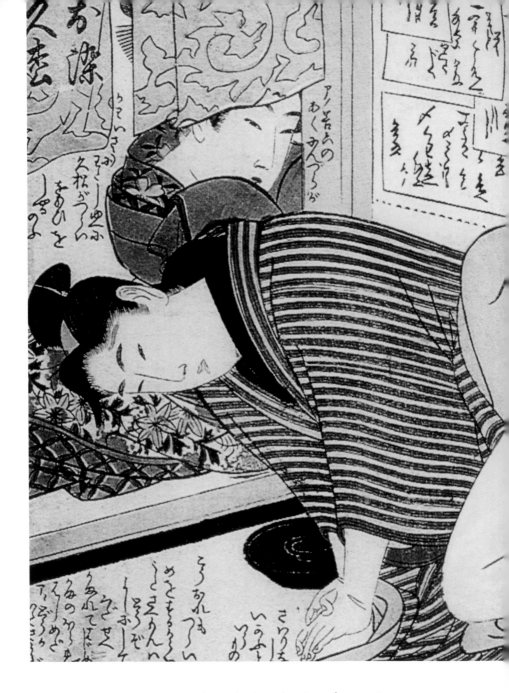

Kitagawa Utamaro *Client and male prostitute.* Late 18th century, Japan

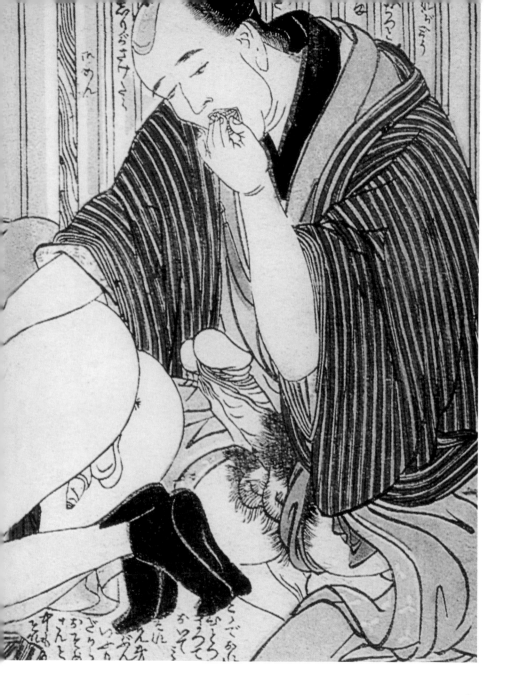

189

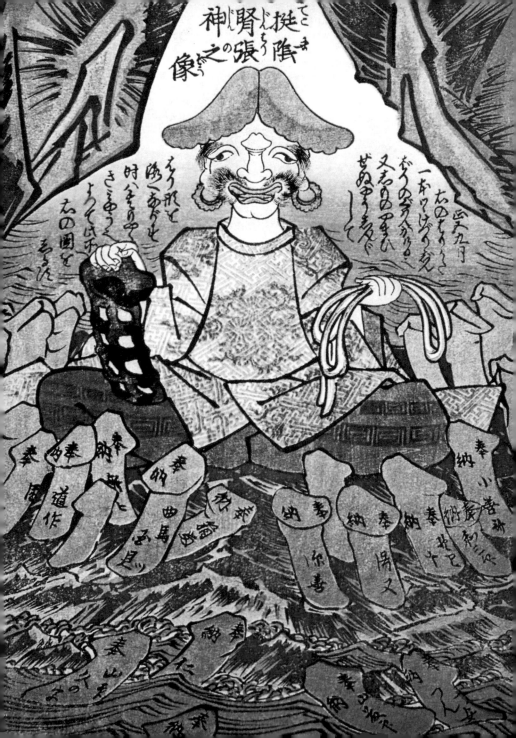

Acknowledgements & Credits:
The publishers wish to thank the copyright holders who greatly assisted in this publication. In addition
to those persons and institutions cited in the captions, the following should also be mentioned:
© Alinari-Giraudon, Paris: 115 © AKG Paris: 135, 137, 138 © 2004 Andy Warhol Foundation for
the Visual Arts/Artists Rights Society (ARS), New York: 21, 22 © Art Works, Pasadena: 128, 129,
172–177 © Bertholet collection: 10, 13, 14, 186, 188/189 © Bildarchiv Preussischer Kulturbesitz, Berlin
(Photo: Jörg P. Anders): 84 © Ferrante Fezzanti, Paris: 138 © The Metropolitain Museum of Art,
New York: 89, 119 © The National Gallery, London: 71 © Photo RMN, Paris (Photo: R. G. Ojeda): 75
© Photo RMN, Paris (Photo: C. Jean): 86 © Photo Vatican Museums, Rome: 116, 120, 160 © SCALA
GROUP S. p. A., Firenze: 68, 96, 114 © Véronique Willemin: 77, 103, 130–133

Text and layout: Gilles Néret, Paris
Editorial coordination: Kathrin Murr, Cologne
Production: Horst Neuzner, Cologne
English translation: Jonathan Murphy, Brussels
German translation: Bettina Blumenberg, Munich

Printed in Italy
ISBN 3–8228–2459–3

◄ Poster describing the range of pleasures available in the early 19th century
in the "floating world" of the Yoshiwara in the province of Tokaido

Tom of Finland:
The Comic Collection
Ed. Dian Hanson / Flexi-cover, 5 vol.
in a slipcase, 960 pp. / € 29.99 /
$ 39.99 / £ 19.99 / ¥ 5.900

Tom of Finland
Micha Ramakas / Flexi-cover,
352 pp. / € 29.99 / $ 39.99 /
£ 19.99 / ¥ 5.900

"These books are beautiful objects, well-designed and lucid." —*Le Monde*, Paris, on the ICONS series

"Buy them all and add some pleasure to your life."

Alchemy & Mysticism
Alexander Roob

All-American Ads 40ˢ
Ed. Jim Heimann

All-American Ads 50ˢ
Ed. Jim Heimann

All-American Ads 60ˢ
Ed. Jim Heimann

Angels
Gilles Néret

Architecture Now!
Ed. Philip Jodidio

Art Now
Eds. Burkhard Riemschneider,
Uta Grosenick

Berlin Style
Ed. Angelika Taschen

Chairs
Charlotte & Peter Fiell

Design of the 20ᵗʰ Century
Charlotte & Peter Fiell

Design for the 21ˢᵗ Century
Charlotte & Peter Fiell

Devils
Gilles Néret

Digital Beauties
Ed. Julius Wiedemann

Robert Doisneau
Ed. Jean-Claude Gautrand

East German Design
Ralf Ulrich / Photos: Ernst
Hedler

Egypt Style
Ed. Angelika Taschen

M.C. Escher

Fashion
Ed. The Kyoto Costume
Institute

HR Giger
HR Giger

Grand Tour
Harry Seidler,
Ed. Peter Gössel

Graphic Design
Ed. Charlotte & Peter Fiell

Havana Style
Ed. Angelika Taschen

Homo Art
Gilles Néret

Hot Rods
Ed. Coco Shinomiya

Hula
Ed. Jim Heimann

India Bazaar
Samantha Harrison,
Bari Kumar

Industrial Design
Charlotte & Peter Fiell

Japanese Beauties
Ed. Alex Gross

Kitchen Kitsch
Ed. Jim Heimann

Krazy Kids' Food
Eds. Steve Roden,
Dan Goodsell

Las Vegas
Ed. Jim Heimann

Mexicana
Ed. Jim Heimann

Mexico Style
Ed. Angelika Taschen

Morocco Style
Ed. Angelika Taschen

**Extra/Ordinary Objects,
Vol. I**
Ed. Colors Magazine

**Extra/Ordinary Objects,
Vol. II**
Ed. Colors Magazine

Paris Style
Ed. Angelika Taschen

Penguin
Frans Lanting

20ᵗʰ Century Photography
Museum Ludwig Cologne

Pin-Ups
Ed. Burkhard Riemschneider

Provence Style
Ed. Angelika Taschen

Pussycats
Gilles Néret

Safari Style
Ed. Angelika Taschen

Seaside Style
Ed. Angelika Taschen

Albertus Seba. Butterflies
Irmgard Müsch

**Albertus Seba. Shells &
Corals**
Irmgard Müsch

Starck
Ed Mae Cooper, Pierre Doze,
Elisabeth Laville

Surfing
Ed. Jim Heimann

Sydney Style
Ed. Angelika Taschen

Tattoos
Ed. Henk Schiffmacher

Tiffany
Jacob Baal-Teshuva

Tiki Style
Sven Kirsten

Tuscany Style
Ed. Angelika Taschen

Women Artists
in the 20ᵗʰ and 21ˢᵗ Century
Ed. Uta Grosenick